LIFE LIBRARY OF PHOTOGRAPHY

The Print

BY THE EDITORS OF TIME-LIFE BOOKS

TIME-LIFE BOOKS, NEW YORK

TIME-LIFE BOOKS

FOUNDER: Henry R. Luce 1898-1967.

Editor-in-Chief: Hedley Donovan
Chairman of the Board: Andrew Heiskell
President: James R. Shepley
Chairman, Executive Committee: James A. Linen
Group Vice President: Rhett Austell

Vice Chairman: Roy E. Larsen

MANAGING EDITOR: Jerry Korn
Assistant Managing Editors: David Maness,
Martin Mann, A. B. C. Whipple
Planning Director: Oliver E. Allen
Art Director: Sheldon Cotler
Chief of Research: Beatrice T. Dobie
Director of Photography: Melvin L. Scott
Senior Text Editors: Diana Hirsh, Ogden Tanner
Assistant Art Director: Arnold C. Holeywell

PUBLISHER: Joan D. Manley
General Manager: John D. McSweeney
Business Manager: John Steven Maxwell
Sales Director: Carl G. Jaeger
Promotion Director: Paul R. Stewart
Public Relations Director: Nicholas Benton

LIFE LIBRARY OF PHOTOGRAPHY
SERIES EDITOR: Richard L. Williams
Editorial Staff for *The Print:*
Editor: Robert G. Mason
Picture Editor: Edward Brash
Text Editors: James A. Maxwell, Peter Chaitin
Designer: Raymond Ripper
Assistant Designer: Herbert H. Quarmby
Staff Writers: George Constable, John Paul Porter,
Peter Wood
Chief Researcher: Peggy Bushong
Researchers: Kathleen Brandes,
Rosemarie Conefrey, Sigrid MacRae,
Gail Hansberry, Shirley Miller, Don Nelson,
Kathryn Ritchell
Art Assistant: Jean Held

Editorial Production
Production Editor: Douglas B. Graham
Assistant: Gennaro C. Esposito
Quality Director: Robert L. Young
Assistant: James J. Cox
Copy Staff: Rosalind Stubenberg (chief),
Ruth Kelton, Florence Keith
Picture Department: Dolores A. Littles,
Barbara S. Simon, Lora T. Moore

Valuable aid was provided by these individuals
and departments of Time Inc.: Editorial
Production, Norman Airey; Library, Benjamin
Lightman; Picture Collection, Doris O'Neil; TIME-
LIFE Photo Lab, George Karas, Herbert Orth,
Gerard Lowther, Al Asnis and Jules Zalon;
TIME-LIFE News Service, Murray J. Gart;
Correspondents Margot Hapgood (London), Maria
Vincenza Aloisi (Paris), Elisabeth Kraemer and
Renée Houle (Bonn), Ann Natanson (Rome),
Robert Kroon (Geneva).

Introduction

Good photographs are seen in the mind's eye before the shutter is tripped, but they are made in the darkroom. For it is in the final stage of photography —in the production of negative and print—that the creative vision is realized in a picture meant to be looked at, admired, perhaps honored.

The technical skills demanded of the printmaker are simple. Modern chemical compounds, processing tanks and printing devices lend themselves to procedures that eliminate guesswork, but they do not eliminate the need for judgment and understanding. The pictorial result of a black-and-white photograph depends entirely on material substance: deposits of metallic silver in the negative and print. Those deposits must convey the vision of the mind's eye, and how they are laid down can be controlled and adjusted at almost every step during processing. It is possible to compensate for out-of-the-ordinary conditions during picture taking—too little light or too much, a scene that is too uniform in tone or too varied. But it is also possible to turn the influences of processing to purely imaginative ends, to alter a scene to suit the photographer's own esthetic intent (however far removed it is from the physical reality of the natural world), or to create a wholly new pattern of lights and darks that could never be found in reality.

The finished print is an end in itself. In its most exalted form it must stand on its own as a true work of art—as do the scores of outstanding prints reproduced in this book. Recognition of the artistic worth of the photographic print came in the early decades of the 20th Century, largely as a result of the efforts of such pioneers as Alfred Stieglitz in the United States, John Heartfield and László Moholy-Nagy in Germany and Man Ray in France. And today artists all over the world continue to explore the esthetic potential of photography, finding new ways to express personal visions in the print.

The Editors

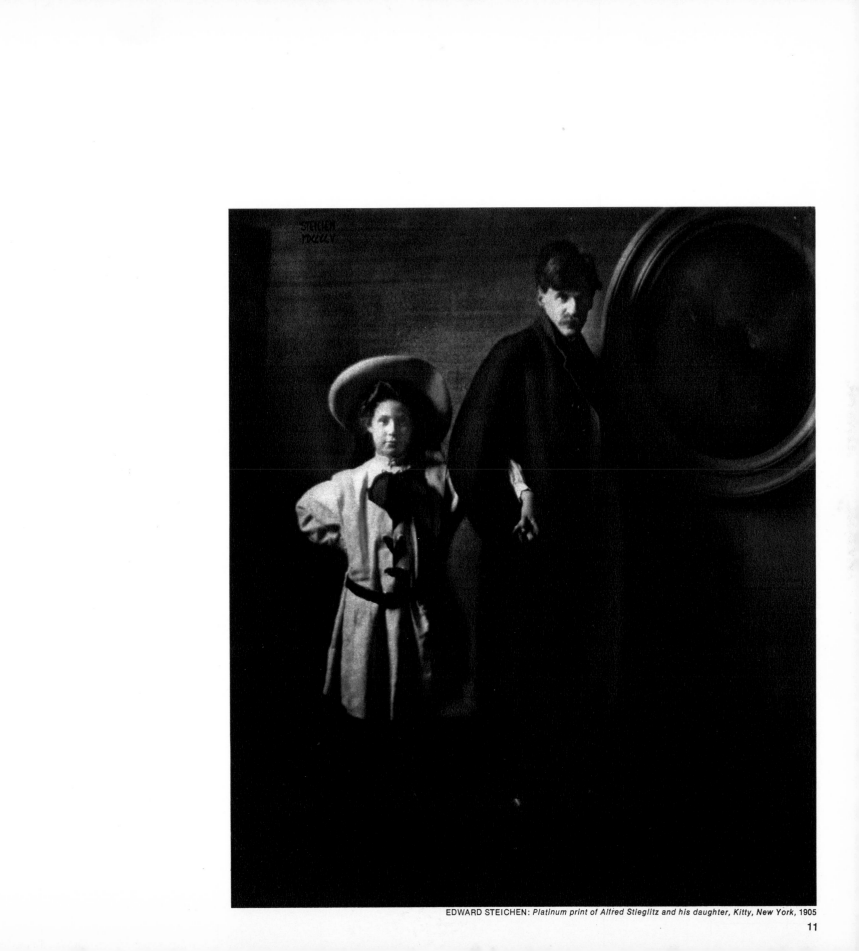

EDWARD STEICHEN: *Platinum print of Alfred Stieglitz and his daughter, Kitty, New York, 1905*

The Artist as Photographer

Today, in New York City alone, more than 15 galleries display and sell the works of art photographers; at the turn of the century, such exhibitions were almost unknown. Today, in the museums of the world, the photographic print occupies an honored place among the arts; in 1900 not a single museum in America included photographs in its permanent collection. Today art critics of major newspapers and magazines regularly review the work of photographers; not many decades ago most would have thought such an assignment beneath contempt—or at least beneath their delicate sensibilities. That such a drastic change has occurred reflects, in very large measure, the achievement of one man—an arrogant, brilliant, irritating, uncompromising, irresistible force of nature named Alfred Stieglitz.

His influence on photography, and, indeed, on all 20th Century art, is hard to overestimate. Not only did he force curators and critics to yield to photography, however hesitantly, a place beside elder media, but by influence, example and sheer force of personality he twice set the style for American photography: first toward romanticized pictures suggesting impressionistic paintings; and later, in a dramatic reversal, toward sharply realistic works that stood proudly on their own as photographs. His interest in creative photography inevitably led him into a companion interest in all forms of art, and he introduced America to what is now called modern art, providing the first exhibits in the United States of the works of such European giants as Cézanne, Matisse and Picasso, as well as calling attention to such young Americans as John Marin, Arthur Dove and Georgia O'Keeffe. For more than four decades he encouraged the intellectually stimulating in art, and in the end he lived to see most of his judgments confirmed by patrons and critics, whose sophisticated tastes could be traced in part to his pioneering efforts.

The son of a prosperous woolen merchant, Alfred Stieglitz was born in Hoboken, New Jersey, on New Year's Day, 1864. His father, Edward, had immigrated from Germany in 1850 and, after achieving modest financial success as a precision instrument manufacturer, joined the Union Army at the outbreak of the Civil War. In 1863 he was discharged a lieutenant and that same year married Hedwig Werner, a young lady of German-Jewish background similar to his own. In the years that followed, the elder Stieglitz prospered greatly in the textile business, so much so that he soon accumulated what in those days was a considerable fortune, $400,000, enough to permit him to retire from business, buy a town house in Manhattan and savor the life of a cultured bon vivant. Thus it was in comfortable, secure surroundings that Alfred Stieglitz and his five sisters and brothers were raised. From fall through spring, life was a round of visits from New York's intelligentsia —successful writers, painters, actors and art patrons, who gathered each Sunday afternoon in the salon of the Stieglitz home for witty and often pen-

etrating discussions. The teen-aged Alfred was not only encouraged to join the conversation but also served as keeper of the keys to the wine cellar. On signal, he ran down the staircases to choose the vintages to slake the thirst of his father's talkative guests.

Summers were rustic. Each June Edward Stieglitz bundled his family and servants off to Lake George in upstate New York. It was at Lake George that young Alfred first took an active interest in photography. It was a characteristic encounter in which the youngster, then age 11, displayed all the self-assurance and forthrightness for which he later became famous. He persuaded a local portrait photographer to permit him in the darkroom to watch a blank plate turn into a photograph and stood by fascinated as the picture appeared as if by magic in the developing bath. But later, as the photographer was re-touching a plate, Stieglitz demanded, "Why are you doing that?" "Makes 'em look more natural," was the photographer's reply. Instinctively recognizing (he later claimed) that the retouching detracted from the impact of the picture's realism, young Stieglitz startled his host with a flat, "*I* wouldn't do that if I were you."

But photography was then only a passing fancy for young Stieglitz. Mathematics had more appeal, and this interest led Alfred, after attending the City College of New York from 1879 to 1881, to Germany—then the world center of learning in science and engineering—to study at the Berlin Polytechnic. At this point, the young man's future seemed assured: a degree in engineering from the prestigious Polytechnic would almost guarantee him a leading role in the rapid industrial expansion of the United States. But one day in 1883 Stieglitz noticed a camera in a Berlin shop window as he was strolling by. Recalling the event many years later, he wrote: "I bought it and carried it to my room and began to fool around with it. It fascinated me, first as a passion, then as an obsession."

Before long Stieglitz had dropped out of his engineering courses and enrolled in a class in photochemistry. Soon he was roaming through the alleys and boulevards of Berlin, making pictures of street scenes, buildings and ordinary people. Often he took the same view several times to satisfy himself that he had captured its essence, and then, when the day's outing was over, returned to his room and, improvising a light-tight tent from a stretched-out blanket, developed his plates. It was ironic that this man, who was to become a master craftsman of the photographic print, never owned a fully-equipped darkroom until a few years before old age and illness forced him to abandon his career as an active photographer.

Frequently Stieglitz left Berlin for picture-taking excursions to south Germany, Switzerland and Italy. Unlike the many photographers of the era who imitated the sentimental scenes of academic paintings by posing costumed

models against painted backdrops, Stieglitz made pictures of real people engaged in workaday activities: peasant girls swinging along a country lane, fishermen beside beached boats, street urchins lounging near a well and laughing at some private joke. This last picture he submitted to a contest that was sponsored by a British magazine, and it won a medal and a small cash award. It had caught the eye of the contest's judge, the prominent photographer Dr. Peter Henry Emerson, who remarked that it was "the only spontaneous work" entered.

Encouragement from so eminent an authority convinced Stieglitz that his future lay with photography. Increasingly, he saw the potential of the photographic print as a work of art, equal in every respect to the work of the painter. And the more he became committed to this view, the angrier he grew when it was challenged. "Artists who saw my early photographs," Stieglitz recalled, "began to tell me that they envied me; that they felt my photographs were superior to their paintings, but that, unfortunately, photography was not an *art*. . . . I could not understand why the artists should envy me for my work, yet, in the same breath, decry it because it was *Machine-Made* —their . . . 'art' painting—because *Hand-Made*—being considered necessarily superior. . . . Then and there I started my fight . . . for the recognition of photography as a new medium of expression, to be respected in its own right, on the same basis as any other art form."

In 1890, after nine years abroad, Stieglitz returned to America. But in the New York of the 1890s, the possibilities of earning a livelihood as a creative photographer were nil, and when his father offered to give him an interest in a small printing and photoengraving business, the young photographer, more out of despair than enthusiasm, seized upon the opportunity. For five years, Stieglitz and his partners tried to run the business. But being totally inexperienced they managed poorly, and finally, in 1895, Stieglitz turned over his share of the business to his partners and returned to his photographic interests on a full-time basis.

For even during these early, painful years in New York, Stieglitz had remained a passionate photographer of life as it is really lived. Carrying a hand-held camera he roamed the city streets, training his lens upon the solitary figure of a streetcar conductor watering his horse or a coachman urging his team up Fifth Avenue in a blizzard. He made picture after picture of city life—brooding and powerful studies that were to become recognized as technical and artistic milestones. His advice to photographers on the making of unposed pictures—using a portable, or "hand," camera—remains as valid today as ever. "The one quality absolutely necessary for success in hand camera work," wrote Stieglitz, "is *Patience*. . . . It is well to choose your subject . . . and carefully study the lines and lighting. After having deter-

mined upon these watch the passing figures and await the moment in which everything is in balance; that is, satisfies your eye. This often means hours of patient waiting. My picture, 'Fifth Avenue, Winter,' is the result of a three hours' stand during a fierce snow-storm . . . awaiting the proper moment.'' Thus, it was at the very moment when such painters as John Sloan and Robert Henri of the ''ashcan school'' were turning to American city streets for their subject matter that Stieglitz was also discovering the beauty to be achieved through realism.

It was during this period, in 1893, that Stieglitz married Emmeline Obermeyer, the wealthy young sister of one of his partners in the ill-fated photoengraving venture. The marriage was never a particularly happy one, for Emmeline, try though she might, could not share her husband's growing enthusiasm for either photography or art. She was a typical well-brought-up young woman of the late Victorian period, primarily concerned with establishing a comfortable home, raising their one child (a girl, Kitty, born in 1898), making grand tours of Europe, and buying clothes. Yet at first Emmeline was an attentive wife. She spent much of her time accompanying Stieglitz to the darkroom of New York's Camera Club, where she dutifully and silently sat watching him develop pictures. In time she became considerably less docile, fretting over her husband's disheveled appearance, objecting to his interests and imploring him to moderate what she considered his scandalous ideas on art and society. Finally, in 1917, after many years of discord, Emmeline ordered her husband out of the house in a fit of jealousy, and the stormy marriage came to an end.

It was in the year of their marriage that Stieglitz took what was to be a fateful step; he assumed the part-time position of editing the prestigious periodical the *American Amateur Photographer,* and with it he also assumed the power to influence the course of photography. Determined to enhance the artistic reputation of the photographic print, he rejected pictures from longtime contributors with the brusque note, ''technically good, pictorially rotten.'' Photographers accustomed to having their work accepted without question bridled at the editor's dictatorial manner, and circulation fell; when the publisher complained, Stieglitz merely ignored him. Even then, at the very beginning of his career, Stieglitz just could not bend with the wind. And it was a matter of principle that brought about his abrupt resignation in 1896, when the publisher refused to print a credit line with pictures by a photographer whose work Stieglitz favored.

By this time, Stieglitz had established an enviable reputation as a photographer. Time and again he had won medals in European competitions, and it was not difficult for him to find a new forum for his ideas. In 1897, at the request of the Camera Club of New York, he took over the quarterly publi-

cation of that society, a magazine he renamed *Camera Notes.* The Camera Club at this time was all but moribund, for the fad for photography as a rich man's pastime was beginning to wear thin. The club's members—most of whom were more interested in socializing than in taking pictures—had even been casting about for a new purpose; some of them had suggested abandoning photography in favor of bicycling.

Stieglitz, of course, had a very different end in mind. He was determined to turn the club, or at least its magazine, into a showcase for the finest photographs to be found. It was his intention, he announced, to find and publish only those photographs that showed "the development of an organic idea, the evolution of an inward principle; a picture rather than a photograph, though photography must be the method of graphic representation." If this meant ignoring the work of prominent club members in favor of nonmembers and even unknowns, Stieglitz could not have cared less. Some members —primarily those of little or no ability—attacked Stieglitz for being undemocratic. They accused him of running the magazine for the benefit of the few and neglecting the majority.

With *Camera Notes* as his personal platform, Stieglitz began gathering about him a circle of talented photographers, many of whom had never before seen their pictures published. There were, among others, Gertrude Käsebier, a New York matron who operated a professional portrait studio. Her métier was idyllic pictures of women and children tastefully posed in the style of old masters. Another New Yorker, Joseph Keiley, a lawyer by profession, submitted moody landscapes to *Camera Notes,* and from Boston, F. Holland Day, a wealthy eccentric, sent in mysteriously lit studies of male nudes. Publication of these photographers encouraged others. From Newark, Ohio, a young bookkeeper named Clarence White sent romantic landscapes and portraits. From Milwaukee, Edward Steichen, an apprentice lithographer, submitted landscapes reminiscent of the work of impressionistic painters. Steichen, who wanted to be a painter, eventually went to Paris to study. On his way Steichen stopped off in New York to salute Stieglitz and to promise that whatever his future as a painter, he would never abandon the art of photography.

Despite the success of *Camera Notes,* Stieglitz was far from satisfied. He may have convinced a few that photography could be an art, but for most of the experts in the art establishment, the picture made with a camera remained a soulless illustration. Faced with their hostility, Stieglitz came to realize that to achieve recognition for photography he had to find new ways to publicize his views. In 1901 the National Arts Club offered an avenue. The Arts Club had been founded by Charles de Kay, art editor of *The New York Times,* and one of the few American critics sympathetic to Stieglitz' ideas.

"One day," reminisced Stieglitz, "he appeared at the Camera Club and said, 'Stieglitz, why don't you show . . . American photographs in New York. . . .' I told him that there was no place in New York fit to hold such a show, and there wasn't. . . . 'Well, de Kay,' I said, 'if your club will give me a room in your gallery to show such prints as I see fit, and let me hang them in my own way, not a soul coming into the room before I open the doors, it's a go.' " It was typical of Stieglitz to demand such complete control; when de Kay suggested that his club's art committee might like to have some say in the matter, Stieglitz archly informed him, "I do not recognize committees. Either you want to show or you don't." De Kay gave in, and for the first time Stieglitz had a gallery in which to exhibit the original prints of photographers who *he* thought merited artistic recognition.

De Kay suggested calling the show an "Exhibition of American Photographs arranged by the Camera Club of New York," but Stieglitz demurred, saying, "Why, the members of the *Camera Club*, the big majority, hate the kind of work I'm fighting for." Then, in a moment of inspiration, Stieglitz said, "I've got it—it's a good one—call it *An Exhibition of American Photography arranged by the Photo-Secession.*"

Thus came tripping off the tongue of its founder the name of one of the major artistic movements of the century. At first, before the show at the National Art Club opened, the Photo-Secession consisted of one man, Alfred Stieglitz; but the name came to stand for those photographers, led by Stieglitz, who had seceded from the majority that was concerned only with technical considerations, who believed that good photography went far beyond technique. Shortly after the opening of the exhibition at the National Arts Club—a show built around the work of Steichen, White, Käsebier and Stieglitz himself, but including pictures by others—the Photo-Secession organized itself into a formal, though loosely structured group whose founding members included the aforementioned photographers. To Stieglitz these photographers formed a photographic elite, bound together not by any adherence to one style, but by their determination to make the world recognize photography "not as the handmaiden of art, but as a distinctive medium of individual expression."

While upholding the banner of photography, most Photo-Secessionists patterned their work quite frankly on painting. The fashionable painters of the day were men like Whistler and Corot, for whom mood was more important than subject. The work of these artists influenced the Photo-Secession toward mist-covered landscapes, blurry cityscapes, women draped in long, flowing garments and rural folk at their chores and pastimes. The light was diffused, the line was soft and details were suppressed in favor of an overall impression.

To achieve these effects, members of the Photo-Secession adopted a variety of techniques for making prints. Many favored gum-bichromate printing, a process that replaced the thin, hard emulsions of standard photographic papers with a thick coating, often tinted, giving the appearance of a painting *(pages 29, 44-45)*. Other members took extraordinary license with the photograph itself, scratching or drawing upon its surface in order to make it look handmade. Indeed, the Photo-Secession, by such tactics, seemed to have confirmed the charges of its critics that in order to qualify as art the photograph was being disguised to mask the fact that it had been made by a machine. But Stieglitz vigorously defended these practices, saying, "The result is the only fair basis for judgment. It is justifiable to use any means upon a negative or paper to attain the desired end." It was a view he had once renounced and would, in but a few years, renounce again; most of his own work at this time was devoid of the intricate darkroom-produced effects favored by his colleagues.

Typical was his now-famous picture of one of New York City's first skyscrapers, the 22-story Flatiron Building, so-named because its narrow, wedge-shaped site at the junction of Fifth Avenue and Broadway dictated a flatiron shape for the structure. Recalling the circumstances surrounding the taking of the photograph, Stieglitz later said: "One day during the winter season of 1902-03, there was a great snowstorm. I loved such storms. The *Flat Iron Building* had been erected. . . . I stood spellbound as I saw that building in that storm. . . . I suddenly saw the building as I had never seen it before. It looked, from where I stood, as though it were moving toward me like the bow of a monster ocean-steamer—a picture of the new America that was still in the making."

For the most part, however, Stieglitz now had precious little time to devote to his own work. In January 1903, about a year after he first used the term Photo-Secession, Stieglitz launched a new magazine, *Camera Work (pages 26-50),* designed to record the achievements of the movement. Financed, edited and published by Stieglitz, it was one of the most beautiful magazines ever published. Its illustrations were often printed in photogravure on fine Japanese tissue and pasted onto the magazine pages by hand. Looking at them is like viewing a portfolio of finely wrought original prints. (Photogravure, which possesses an unsurpassable ability to reproduce the nuances of fine photographs, has been used to print the black-and-white pictures in this book.) *Camera Work's* articles were printed on a luxurious, soft paper in a handsome type and were often written by leading authors of the day. Maurice Maeterlinck, George Bernard Shaw *(pages 33-36)* and Gertrude Stein contributed to *Camera Work*—sometimes on subjects only indirectly related to photography. Within its elegant pages, new and unknown photogra-

phers—and eventually, new and unknown painters—had their first showing.

In addition to publishing *Camera Work,* Stieglitz arranged for the exhibitions of the work of Photo-Secession members, dictating where the prints would be shown and under what conditions they would be exhibited. Sometimes these restrictions angered his colleagues, particularly those who hungered for more outlets for their work. But Stieglitz' dictatorial methods got results. In 1904, for example, he succeeded in arranging two important shows, one at the Corcoran Gallery of Art in Washington, D.C., the other at the Carnegie Institute in Pittsburgh.

While he was assembling the Corcoran Gallery show, Stieglitz got help from his friend Edward Steichen. The young painter-photographer had returned from Europe the year before, and to support himself in New York he opened a portrait studio. Stieglitz helped him get one of his first commissions, a portrait of J. P. Morgan that shows the noted financier glaring into the camera, his hand apparently brandishing a dagger. (The "weapon" is actually a highlight on the arm of the chair in which he was sitting.) The fame this picture has attained is ironic, for it was intended only to be a study, not a showpiece. Steichen made the photograph for the portrait painter Fedor Encke, who commissioned it to work from while painting. But the Encke painting turned out to be far less effective than the photograph from which it was made, and Steichen's work is remembered as the portrait. It lays bare the arrogance and disdain of the subject, the most powerful man of his time, for only the instantaneous directness of the camera in the hands of an artist could capture the force of such a personality. Some years after Steichen had made the portrait and had turned the original print over to Stieglitz, Morgan became interested in buying it. He sent an assistant to Stieglitz to negotiate for its sale, but Stieglitz insisted that he would not sell the portrait at any price. "What," exclaimed Morgan when told of the abortive transaction, "is there anything that cannot be bought?" Morgan's disbelief probably turned to astonishment when Stieglitz then offered to give him the portrait without charge on condition that it be hung at The Metropolitan Museum of Art, an institution of which the magnate was a trustee. Morgan, a dyed-in-the-wool conservative on artistic matters, of course refused the offer.

It was Steichen who suggested what turned out to be a lifetime mission for Stieglitz: that of an art exhibitor and educator of the public's taste. Despite the success of the Corcoran and Carnegie Institute exhibits, Stieglitz was still having trouble arranging shows on his terms. In 1905 Steichen proposed that they open up their own gallery in the flat next door to the Steichen apartment, on the top floor of a town house at 291 Fifth Avenue. Stieglitz agreed, although at first he may not have thought of this venture as more than an informal and perhaps temporary expedient that would provide

Photo-Secession photographers with a place where they could gather, discuss their work and exhibit. On November 24, 1905, the Little Galleries of the Photo-Secession (soon it would be known simply by its street address, 291) opened. The rooms were small, and Steichen had covered the walls with burlap in various subdued colors, making an excellent backdrop for the photographs to be shown there. The last one-man show of the first full season was devoted entirely to the work of Edward Steichen, and after it closed the young painter-photographer announced to Stieglitz that he was once again going to Europe.

The impending departure of Steichen posed a problem for Stieglitz. If the gallery was to continue in operation it would obviously consume more and more of his energies. Evidently this was a problem that was quickly resolved in Stieglitz' mind, for in fact, if not in name, he was already becoming a professional advocate of contemporary art. He was not an art dealer in the sense that he was operating a business, for to Stieglitz the idea of turning a profit from any of the galleries he was to operate was abhorrent. His contempt for those who made money by selling works of art was recorded by his longtime friend, the poet and critic Herbert J. Seligmann, who wrote: "Of art dealers, Stieglitz remarked more than once that the essential difference between a dealer and the madam of a house of prostitution was that [though] the madam, at need, could substitute for a girl, the art dealer could not for an artist."

In the world of New York artists and critics, 291 was an instant success. Not only was the work of photographers exhibited, but as the years went on, talented and little-known artists in other media found a welcome extended to them in Stieglitz' gallery. For Stieglitz was now growing increasingly restive in his role as a combination guru and publicist for the Photo-Secession photographers. "Jealousies had been developing . . . amongst the Secessionists," he recalled. "They had come to believe that my life was to be dedicated solely to them and did not realize that my battle was for an idea bigger than any individual." That idea was indeed big: to present to the American public the best that modern art had to offer, whether in photography, painting or sculpture. Accordingly, in 1907 when Steichen, then living in Paris, cabled asking if Stieglitz would be interested in showing drawings made by the great French sculptor Auguste Rodin, Stieglitz cabled back an enthusiastic yes. The Rodin exhibition opened at the Little Galleries on January 2, 1908, to a press that was generally friendly, although one critic observed pessimistically—and with some truth—that Rodin's work would "doubtless . . . be pretty nearly incomprehensible to the general public." The Rodin show was followed in April 1908 with an exhibition devoted to another European artist whose work was even less comprehensible—and, indeed, proved offensive to almost all the critics. The artist was Henri Matisse.

Matisse, leader of *Les Fauves,* the "wild beasts" whose violent colors and unfamiliar distortions had shocked the art establishment, naturally attracted Steichen, as well as many other young artists then studying in Paris. Steichen had no difficulty arousing an equal enthusiasm in Stieglitz, and soon a selection of Matisse lithographs, etchings, watercolors and drawings was hanging on the walls of 291. It was the first Matisse show in America, and predictably it set off a storm of protest. Matisse's "splotches of color," as one critic described them, to say nothing of his frankly erotic and unabashed rendering of the female form, were much too daring for American tastes, and Stieglitz, for his pains in bringing the dangerous works of Matisse to the public, was pilloried as a threat to the morals of America.

If the indignant howls of the art establishment had any effect upon Stieglitz at all, it was merely to set him ever more firmly in his ways. During the next few years he introduced America to the work of such other little-known Europeans as Picasso, Braque and Cézanne, and also presented the paintings of several of America's most promising painters—Marin, Dove, Alfred Maurer and Marsden Hartley—then considered as shocking as the radical Frenchmen. It was curious, said an editorial comment in *Camera Work,* that "while men of the lens busied themselves with endowing their new and most pliable medium with the beauties of former art expressions, those of the brush were seeking . . . a technique that was novel and—unphotographic."

Stieglitz himself was now sensing that the ideas of the Photo-Secession had by now been developed to their limit, and in 1909 he agreed to organize one last great exhibition of the members' work. It was held in the neoclassic halls of the Albright Art Gallery in Buffalo, New York, and occupied well over half the museum. From November 4 through December 1, 1910, a steady stream of visitors attested to the show's popularity with the general public, and it won equal acclaim from the critics. In a sense, Stieglitz had achieved his goal: photography was now accepted in a major museum as a medium of expression fully as valid as painting. But success had left a somewhat bitter taste in Stieglitz' mouth. In its victory, Photo-Secession had reached an artistic dead end; its emphasis was on pictorial expression and this placed it in the rear guard rather than the vanguard of the arts.

In his own work, Stieglitz had already begun to turn away from the misty, paintinglike effects of the Photo-Secession, and he now concentrated on the detailed clarity that gives the photographic process its remarkable sense of truthfulness. "After claiming for photography an equality of opportunity with painting," wrote his friend Charles Caffin in *Camera Work* in 1912, "Stieglitz turns about and with devilishly remorseless logic shows the critics, who have grown disposed to accept this view of photography, that they are again wrong." Instead of insisting that painting and photography were equals, that

what could be done in one medium could be done in another, Stieglitz began to search for esthetic values that applied to photography alone.

It was in the work of a young New Yorker, Paul Strand, that Stieglitz began to see his new vision for photography realized. In 1915 Strand brought Stieglitz a group of photographs he had taken. Some were cityscapes; others were close-ups of objects that caught his fancy—a picket fence *(page 50),* a group of bowls *(page 48).* All of them revealed a startling new approach that suggested how photographers might explore the unfamiliar worlds of art opened up by such painters as Sloan and Henri in America and Picasso and Braque in Europe. In the streets of the city Strand found terror, the terror of the urban environment: a blind woman *(page 49),* a fat man and elderly derelicts, unaware of the camera, play out the tragedy of their existence against the looming, threatening forms of the buildings they inhabit. Where Stieglitz' prints of 15 or so years before had suggested a mood of loneliness and isolation, Strand's pictures forthrightly declared that the life of urban man was a nightmare existence. And in his pictures of bowls and picket fences there was a new kind of photographic beauty, not the misty evocations of the Photo-Secessionists, but hard, sharp patterns of light and shadow abstracted from the natural world by the camera.

In 1916 Stieglitz gave the 26-year-old Strand a show at 291, the only purely photographic exhibit during the last four years of the gallery's existence. He also devoted the last two issues of *Camera Work* to him, calling Strand "the man who has actually done something from within . . . who has added something to what has gone before." He spoke of Strand's work as "devoid of flim-flam, devoid of trickery and of any 'ism,' devoid of any attempt to mystify an ignorant public, including the photographers themselves. These photographs are the direct expression of today."

They were also harbingers of things to come. Strand was finding images and symbols within the real world to express his innermost thoughts, and in that synthesis of reality and abstraction lay a new field for photography —and particularly for Stieglitz—to explore. With Stieglitz and Paul Strand leading the way a new photographic esthetic that mixed symbolism with realism was born: an esthetic that continues to this day to be a powerful influence among art photographers.

The esthetic turning point marked by Strand's photographs came at a turning point in Stieglitz' own life, personal as well as professional. Not only was his marriage breaking up, but the financial burden of maintaining his gallery and magazine was growing onerous. Stieglitz had a small annuity from his father, but it was insufficient to make up the deficits that were taken for granted in the operation of 291 and *Camera Work.* Even the times were sadly out of joint for Stieglitz. The American entry into World War I caused

him considerable pain, setting as it did the nation of his birth against the land of his student days. In addition to his financial and emotional troubles, the building that housed his gallery was torn down in 1917. He closed 291, and *Camera Work,* deserted by subscribers who could not follow Stieglitz' switches in artistic goals or objected to the emphasis on contemporary painting within its pages, ceased publication.

But Stieglitz was already moving in a new direction. In 1915 a young woman appeared at 291 with a portfolio of drawings under her arm. The drawings had been sent to her by an art teacher from Texas, Georgia O'Keeffe, with the injunction that they be shown to no one. She was so impressed by the drawings that she ignored the request and brought them to Stieglitz, who took one look and exclaimed, "At last, a woman on paper."

When he exhibited the O'Keeffe drawings at 291, they caused a stir among artists and critics. The critic William Murrell Fisher was to sense in O'Keeffe's work "visible . . . emotional forms quite beyond the reach of . . . reason—yet strongly appealing to that . . . sensitivity in us through which we feel the grandeur and sublimity of life." Inevitably word of the exhibit reached Miss O'Keeffe. She felt her privacy had been invaded and she appeared one day at 291 in a cold fury—a girl with "fine enormous eyes," Stieglitz later recalled. "She was wearing a black dress with a white collar and had a Mona Lisa smile. She said 'I want those pictures taken down.' "

"Who are you?" Stieglitz asked, and she replied, "Georgia O'Keeffe."

Stieglitz quickly soothed her injured feelings and she left the pictures where they were. So began a lifelong relationship that was to culminate in marriage in 1924. Unlike Stieglitz' first marriage, this one was marked by mutual understanding and affection despite many long separations—O'Keeffe was stifled by the city and spent much of her time working in the mountains of New Mexico, while Stieglitz was committed to New York and suffered from a heart ailment that precluded living at mountainous altitudes. Stieglitz often acknowledged his spiritual debt to O'Keeffe. In 1922, when they had known each other for six years, he remarked to fellow-photographer Edward Weston: "Friends made me out a god, when all I asked was to be treated as a human being. . . . There has been one who stood by me through it all—a girl from Texas. You see her paintings here stacked all around this room, this room that my brother allows me. . . . I have nothing left, deserted by friends and wife and child—yet in no period of my life have I been so enthusiastic and interested in photography and anxious to work."

With Georgia O'Keeffe encouraging him, Stieglitz was able to get on with the difficult task of finding a new esthetic in his own photography. He continued his experiments with a new kind of symbolic photography, trying to give voice to his feelings about life in pictures of clouds, trees, fields of

grass. He also began a most unusual project, a pictorial biography of his life with Georgia O'Keeffe. He took literally thousands of pictures of her and discovered that expression was not limited to the face. In her hands, in her legs, in her body, as well as in her face, he found images for his camera that seemed to have in them the breath of life.

This work remained unknown to the general public for some time, since with the death of 291 and *Camera Work,* Stieglitz dropped out of sight. When a retrospective show of his work—his first one-man show in seven years —was held at the Anderson Galleries in New York City in 1921, people came to pay tribute to an old master. They left marveling at a new master. The photographs of Georgia O'Keeffe, a series Stieglitz thought of as a composite portrait, were recognized as more than a portrait of a single individual. Stieglitz was using his camera to explore a deeply personal relationship, the relationship between a man and a woman. In doing so he transcended private emotion to create images that expressed the sublime nature of all human relationships. The O'Keeffe portraits are symbols, and it was this use of photography that occupied Stieglitz for the rest of his life.

The 1921 show marked Stieglitz' re-emergence not only as an active photographer but also as a major influence in the world of art. By 1928 the very apex of the artistic establishment, The Metropolitan Museum of Art in New York, added to its permanent collection a group of his prints. The most hallowed sanctuary of fine art in America had thus been breached by photography, and with this triumph the place of photography among the recognized arts was secure. But Stieglitz was more interested in the opinions of the young photographers and painters who gathered about him in his galleries: the Intimate Gallery, opened in 1925, and its successor, An American Place, which he operated from 1929 until his death in 1946. Both were homes for fine art and creative artists, not art sales rooms. For the art collector, the chic who merely wished to purchase "the latest thing" and the investor who bought in hopes of making a profit on resale, Stieglitz had only scorn. An announcement for An American Place summed up his straitlaced philosophy of running a gallery. In bold letters the card stated: "*No* formal press views; *No* cocktail parties; *No* special invitations; *No* advertising; . . . *Nothing* asked of anyone who comes." Stieglitz could also have added, "no listing in the telephone directory." When asked why he had no phone listing, Stieglitz archly replied: "If people really need a thing they will find it."

An incident recalled by Dorothy Norman, a close friend, illustrates Stieglitz' approach:

One day when there are pictures on the walls, a woman who has been walking about looking at them suddenly addresses Stieglitz, who stands

there as usual, seemingly as integral a part of the Place as the walls themselves:

"This is a very exciting show. What else ought I to see in New York?"

Stieglitz replies: "I have no idea what else you ought to see. . . ."

Woman: "Could you tell me, by any chance, where Mr. Stieglitz' gallery is? I hear that he has the finest things in New York, but I cannot find his gallery listed anywhere."

"Mr. Stieglitz has no gallery."

"You are mistaken. I was distinctly told that he has, and that I must surely go there when I came to New York."

Stieglitz finally raises his voice: "Well, I ought to know. I am Mr. Stieglitz and I tell you he has no gallery."

The woman, utterly taken aback by this apparent madman, fled. When Stieglitz was asked why he had not been more helpful, he replied: "Something more was at stake than her knowing where she was for the moment. And I am not in business. I am not interested in exhibitions. . . . I am not a salesman, nor are the pictures here for sale, although under certain circumstances certain pictures may be acquired."

As before, Stieglitz seldom took a commission for his services. For his own work, he almost always refused payment. Once, when he was so short of funds he accepted a fee for a portrait, he apologized. "I hated to take the money," he said. "It was against my principles. . . . What is a masterpiece worth? A million dollars. . . . But on the other hand, as public property, it has no selling price."

Day after day, through the 1930s and into the 1940s, he walked from his apartment to An American Place, there to sit or lie upon a camp cot, waiting for whatever visitors the day might bring. He had become an institution, and photographers and painters from every corner of the world visited him in the sparse gallery. It was at his apartment, only a stone's throw from his beloved American Place, that he suffered a fatal stroke on July 10, 1946—three days later, he was dead at the age of 82. In his obituary notice in *The New York Times,* a writer was quoted as saying of Alfred Stieglitz: "A most incessant talker, he raised his voice for more than half a century to proclaim his powers as a prophet soothsayer. . . . With absolute faith in his own vision, . . . he was long ago recognized as a born leader and he has not neglected his eminence. He has not been defeated because he has not acknowledged defeat; . . . and his voice will go on ringing down the corridors of art forever."

Stieglitz, perhaps, wrote a better summation of his life and career for the catalogue of his 1921 one-man show: "I was born in Hoboken. I am an American. Photography is my passion. The search for Truth my obsession." □

Photography's Lavish Showcase

As the big gun in their campaign to win photography its own place among the fine arts, Alfred Stieglitz and his band of followers, the Photo-Secessionists, brought out a new camera magazine in 1903. It proved to be a weapon of very high caliber. With a boldly artistic cover *(opposite),* elegant type, textured paper, such noted writers as playwright George Bernard Shaw *(pages 33-36),* and pages filled with superbly reproduced pictures, *Camera Work* was one of the handsomest magazines of any kind that was ever published.

It was also one of the most influential journals in the annals of photography. Stieglitz' only requirement was that anything he printed must be worthy of the word "art." Under this ambiguous aegis *Camera Work* offered, in its fifty issues, pictures that ranged from meticulously realistic recordings of the real world *(pages 49 and 50)* to hazy pseudo-paintings *(pages 39 and 45).* Indeed, painting became at one point the magazine's main fare *(pages 46-47).*

The hand that held everything together was beauty—of subject matter, of printing technique and of the magazine itself. In *Camera Work,* luxury was a necessity. Stieglitz, in the double-barreled role of editor and publisher, saw to it that, as he assured the magazine's subscribers, "No expense was stinted." He promised them, and he delivered, "a magazine more sumptuous than any other which had ever been attempted in photography."

The subscription rate also was sumptuous: eight dollars—the equivalent of about $25 now—for four issues. Even so Stieglitz had to pour in large amounts of his own money to keep the standards up. To get the highest possible fidelity in his reproductions, he used not one, but half a dozen different engraving and printing processes.

The one printing method that brought *Camera Work* enduring renown, however, was photogravure. This was (and still is) the finest of all processes for reproducing black-and-white (and other single-color photographs). It actually forms an image on paper in much the same way that darkroom chemicals do. Just as the darkroom process deposits chemicals in varying thicknesses to build up the light and dark tones of a photographic print, the photogravure process deposits ink in various thicknesses to build up light and dark portions of the reproduction. A good photogravure and the photograph from which it was made are all but indistinguishable to the naked eye. This was gratifyingly evident when a collection of original photographs from *Camera Work* contributors once was lost on the way to an exhibition in Brussels. The sponsors simply clipped some pictures from the magazine, had them mounted and hung, and no one was the wiser.

With *Camera Work* carrying their artistic banner, the Photo-Secessionists by 1910 had largely won the recognition they sought. Stieglitz then increasingly turned the magazine to promoting modern painting and sculpture. Subscribers deserted in droves. From a peak of 1,000 in the early years, the paying customers dropped to just 37 by the time Stieglitz called it quits in 1917. Momentarily dispirited, he made a drastic break with the past, burning hundreds of leftover copies. But canny art dealers saved a few. Half a century later, some of the more famous issues were selling for as much as $500 each.

A PHOTOGRAPHIC QUARTERLY
· EDITED AND PUBLISHED BY ·
ALFRED STIEGLITZ NEW YORK

Allegories were a favorite subject of Gertrude Käsebier, a highly successful New York portraitist. This picture was one of a famous series depicting the joys and duties of motherhood. The mistily romantic style, perhaps a reflection of Mrs. Käsebier's early preoccupation with painting, was a very popular one at the time and many similar pictures appeared in "Camera Work." Mrs. Käsebier was much admired by fellow photographers for her skill as well as charm and tact, and it came as no surprise that "Camera Work" devoted its first issue mainly to showing and discussing her pictures.

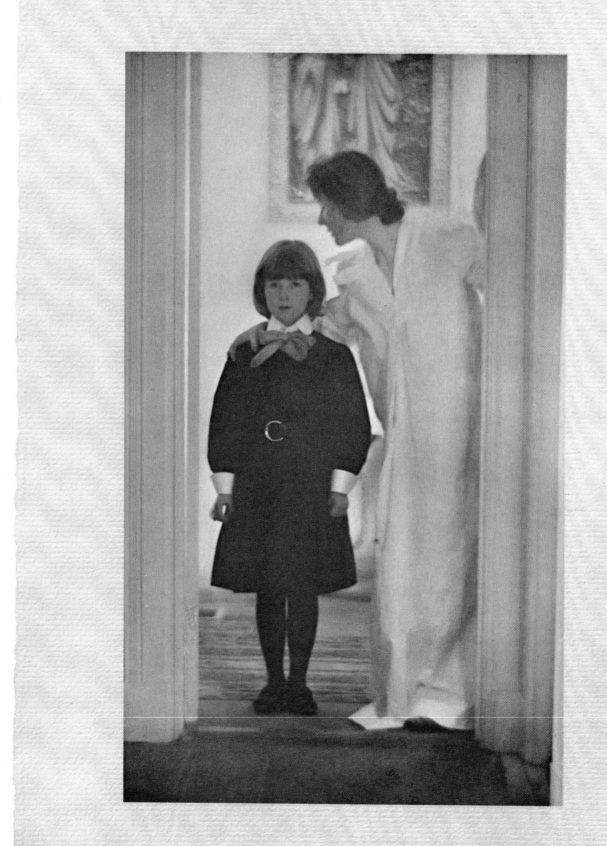

GERTRUDE KÄSEBIER

Blessed Art Thou among Women, c.1898

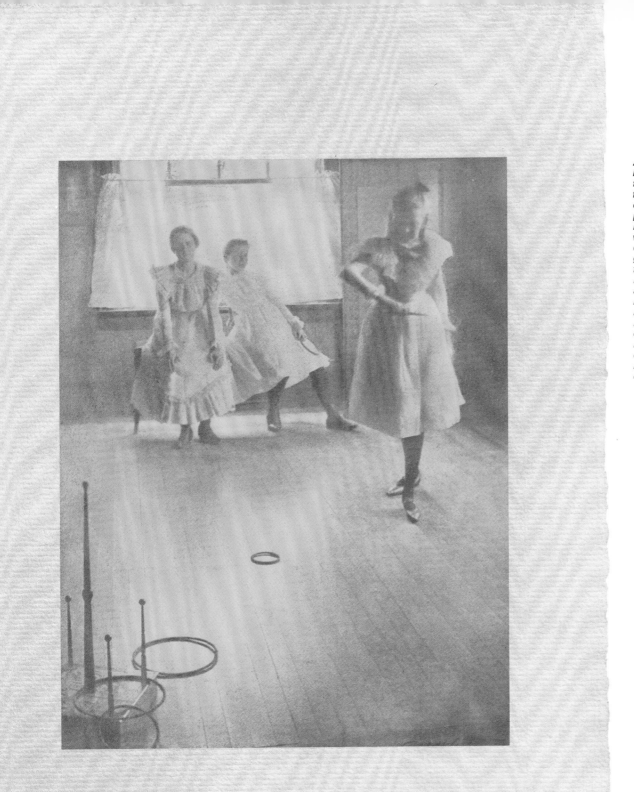

After sixteen years as a bookkeeper in Newark, Ohio, Clarence White turned full time to the camera and was appointed to the faculty of Columbia University, becoming one of the best-known and most influential photographers in the country. His pictures, like those of Mrs. Käsebier (opposite), were carefully composed but had a natural, easy-going ambience, as in this scene of girls at play. White, together with many other first-rate photographers of the time, did not rely entirely on the camera for his effects, and he varied his printing procedure if he felt it would improve the picture. Here, for instance, he has blotted out detail in the lower half of a window to keep it from cluttering up the background. The warm, reddish cast was achieved by pigment that creates the image in the so-called gum-bichromate printing process, which White employed to make this photograph.

CLARENCE H. WHITE

Ring Toss, 1899

As editor of "Camera Work," Alfred Stieglitz welcomed a variety of styles from others, but he himself generally followed a straightforward approach. He meticulously controlled the planning of a picture but then let the camera record the scene without further interference. Here he has carefully chosen his place (New York's lower Fifth Avenue) and his time (he often waited hours for just the right moment to snap the shutter). The result is a deliberately conceived scene, plainly recorded. Although the title suggests that Stieglitz intended to use this picture as a poster, his real purpose was to show how photography could create a poster design.

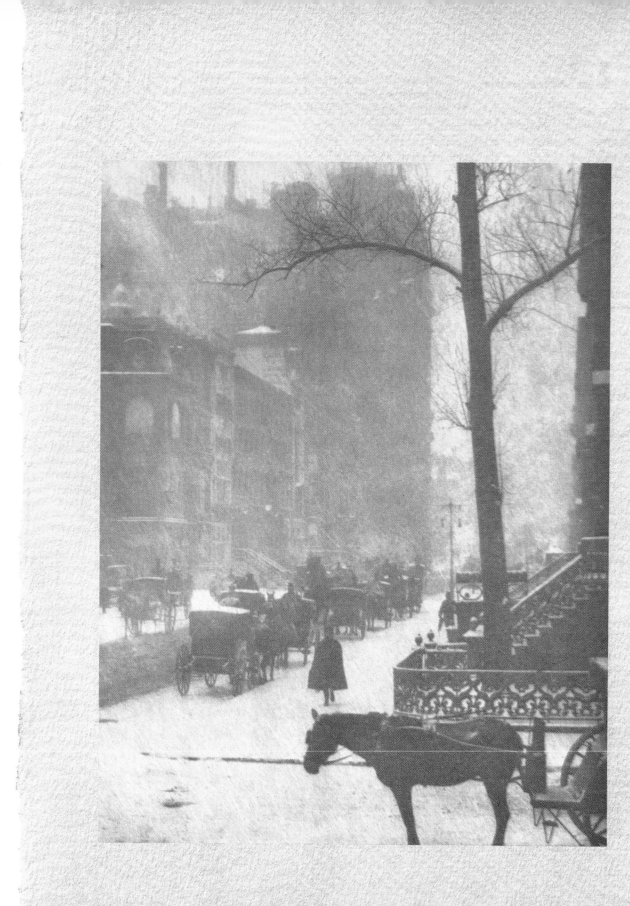

ALFRED STIEGLITZ

The Street, Design for a Poster, c. 1900

Denver amateur Harry Rubincam was, like Stieglitz, an early exponent of the straightforward approach. This picture has been called a landmark in modern photography because of its natural lighting, stopped motion and spur-of-the-moment realism. The photogravure plates for this and the picture opposite were engraved for "Camera Work" directly from the photographers' negatives, bypassing the usual step of working from photographic prints. Thus the photogravure magazine reproductions were, in effect, original prints.

HARRY C. RUBINCAM

In The Circus, 1905

To catch the brilliant shafts of light and subtle shadows of cathedrals, the English photographer Frederick Evans almost always printed his pictures by the platinotype process, using a paper that was coated with platinum compounds rather than silver ones. Platinum yields a range of delicate tones and subtly shaded highlights that no other metal can match. There was no one who appreciated such esthetic technicalities more than playwright George Bernard Shaw, who wrote the following profile of Evans and his work. A fervid and knowledgeable amateur himself, Shaw recognized the artistry that was to be found in Evans' prints: "You occasionally hear people say of him that he is 'simply' an extraordinarily skilful printer in platinotype. This, considering that printing is the most difficult process in photography, is a high compliment."

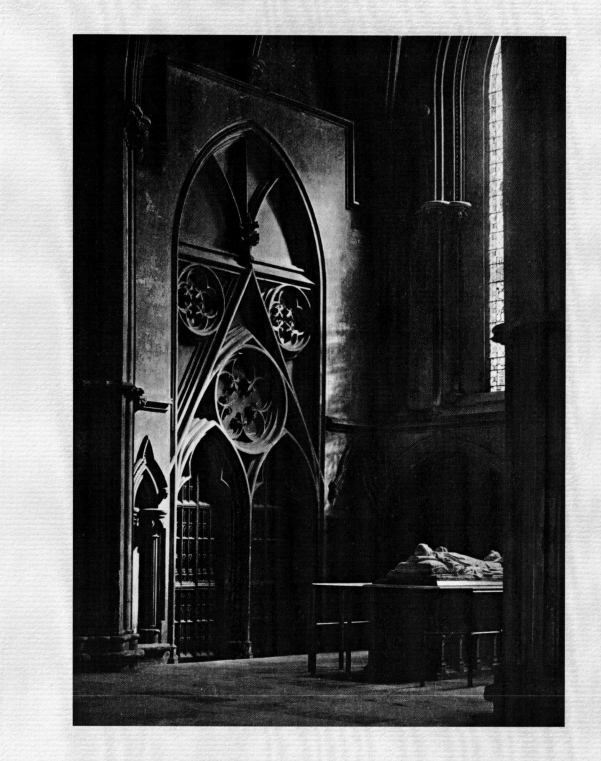

FREDERICK H. EVANS

York Minster: In Sure and Certain Hope, c. 1904

EVANS—AN APPRECIATION.

YES: NO doubt Evans is a photographer. But then Evans is such a lot of things that it seems invidious to dwell on this particular facet of him. When a man has keen artistic susceptibility, exceptional manipulative dexterity, and plenty of prosaic business capacity, the world offers him a wide range of activities; and Evans, who is thus triply gifted and has a consuming supply of nervous energy to boot, has exploited the range very variously.

I can not say exactly where I first met Evans. He broke in upon me from several directions simultaneously; and some time passed before I coördinated all the avatars into one and the same man. He was in many respects an oddity. He imposed on me as a man of fragile health, to whom an exciting performance of a Beethoven Symphony was as disastrous as a railway collision to an ordinary Philistine, until I discovered that his condition never prevented him from doing anything he really wanted to do, and that the things he wanted to do and did would have worn out a navvy in three weeks. Again, he imposed on me as a poor man, struggling in a modest lodging to make a scanty income in a brutal commercial civilization for which his organization was far too delicate. But a personal examination of the modest lodging revealed the fact that this Franciscan devotee of poverty never seemed to deny himself anything he really cared for. It is true that he had neither a yacht, nor a couple of Panhard cars, nor a liveried domestic staff, nor even, as far as I could ascertain, a Sunday hat. But you could spend a couple of hours easily in the modest lodging looking at treasures, and then stop only from exhaustion.

Among the books were Kelmscott Press books and some of them presentation copies from their maker; and everything else was on the same plane. Not that there was anything of the museum about the place. He did not collect anything except, as one guessed, current coin of the realm to buy what he liked with. Being, as aforesaid, a highly susceptible person artistically, he liked nothing but works of art: besides, he accreted lots of those unpurchasable little things which artists give to sympathetic people who appreciate them. After all, in the republic of art, the best way to pick up pearls is not to be a pig.

But where did the anchorite's money come from? Well, the fact is, Evans, like Richardson, kept a shop; and the shop kept him. It was a book-shop. Not a place where you could buy slate-pencils, and reporter's note-books, and string and sealing-wax and paper-knives, with a garnish of ready-reckoners, prayer-books, birthday Shakespeare, and sixpenny editions of the Waverley novels; but a genuine book-shop and nothing else, in the heart of the ancient city of London, half-way between the Mansion House and St. Paul's. It was jam full of books. The window was completely blocked up with them, so that the interior was dark; you could see nothing for the first second or so after you went in, though you could feel the stands of books you were tumbling over. Evans, lurking in the darkest

the obscurest detail in the corners seems as delicately penciled by the darkness as the flood of sunshine through window or open door is penciled by the light, without a trace of halation or over-exposure, will convince any expert that he is consummate at all points, as artist and negative-maker no less than as printer. And he has the "luck" which attends the born photographer. He is also an enthusiastic user of the Dallmeyer-Bergheim lens; but you have only to turn over a few of the portraits he has taken with a landscape-lens to see that if he were limited to an eighteenpenny spectacle-glass and a camera improvised from a soap-box, he would get better results than less apt photographers could achieve with a whole optical laboratory at their disposal.

Evans is, or pretends to be, utterly ignorant of architecture, of optics, of chemistry, of everything except the right thing to photograph and the right moment at which to photograph it. These professions are probably more for edification than for information; but they are excellent doctrine. His latest feat concerns another facet of him: the musical one. He used to play the piano with his fingers. Then came the photographic boom. The English critics, scandalized by the pretensions of the American photographers, and terrified by their performances, began to expatiate on the mechanicalness of camera-work, etc. Even the ablest of the English critics, Mr. D. S. McCall, driven into a corner as much by his own superiority to the follies of his colleagues as by the onslaught of the champions of photography, desperately declared that all artistic drawing was symbolic, a proposition which either exalts the prison tailor who daubs a broad arrow on a convict's jacket above Rembrandt and Velasquez, or else, if steered clear of that crudity, will be found to include ninety-nine-hundredths of the painting and sculpture of all the ages in the clean sweep it makes of photography. Evans abstained from controversy, but promptly gave up using his fingers on the piano and bought a Pianola, with which he presently acquired an extraordinary virtuosity in playing Bach and Beethoven, to the confusion of those who had transferred to that device all the arguments they had hurled in vain at the camera. And that was Evans all over. Heaven knows what he will take to next!

GEORGE BERNARD SHAW.

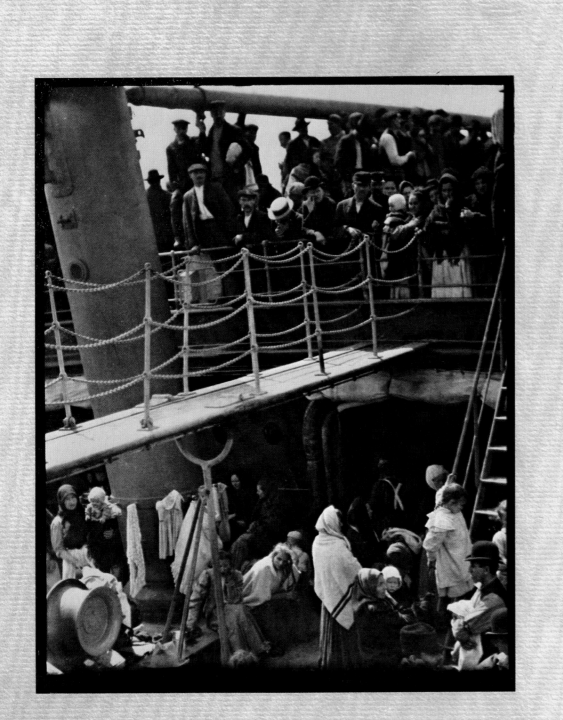

During a crossing to Europe, Stieglitz
chanced to look down from the first-class
deck to the steerage, where passengers
huddled amid walkways and funnels. He was
struck by the random patterns made by men
and machinery, and he sensed a strength
and clarity of purpose in the people below
him. "I saw a picture of shapes, and
underlying that the feeling I had about life,"
he said. Quickly he got his Graflex, the large
(4 x 5) hand-held single-lens reflex that
was to become a favorite of many serious
photographers, and exposed his last plate.
In later years he said that if all his other
pictures were somehow lost he would be
content to be remembered for this one alone.

ALFRED STIEGLITZ
The Steerage, 1907

Among the "Camera Work" contributors who reworked their developed negatives, Frank Eugene went further than most. Having started out as a painter, he still found it hard to keep his hands off his pictures after switching to photography. An extreme example of his tampering is this picture of two nudes. Perhaps to subdue a highlight or to produce one, or simply to avoid a machine-made look, Eugene scratched the negative of Adam and Eve so that his final print (right) looked more like an etching than a photograph. While some critics were shocked by such manipulation, considering it a dishonest twisting of the camera's truthful vision, they had to admit that the results had a certain semblance of art—and that was what counted in "Camera Work."

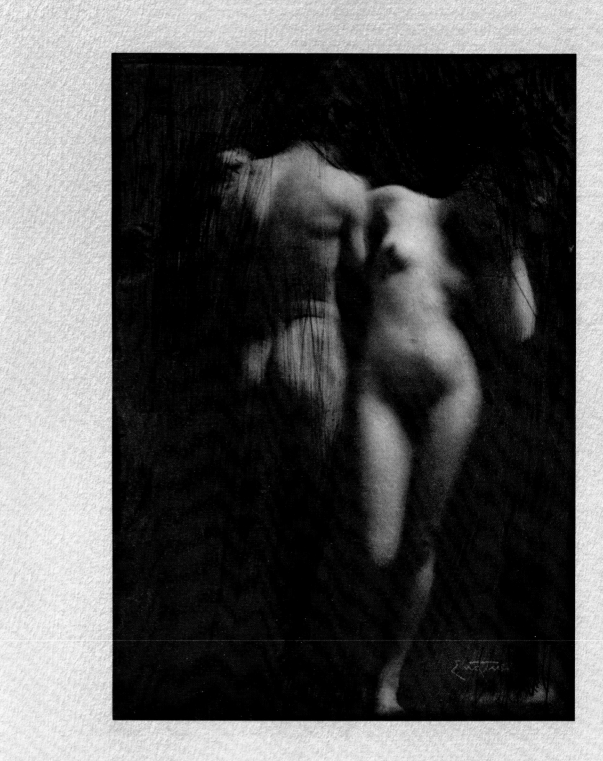

FRANK EUGENE

Adam and Eve, c. 1910

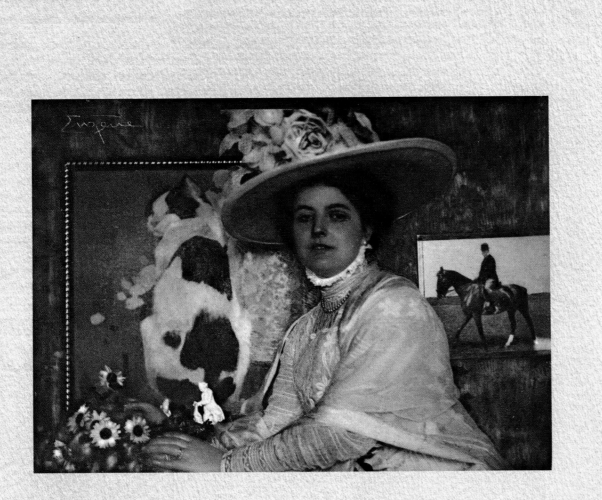

Some painters' styles as well as their techniques showed up now and then in Eugene's photographs. An American, he had spent most of his career in Europe, where early in the century he mingled with painters and got to know the work of various schools. This portrait of a German lady uses both a pose and some of the trappings—fancy hat, busy background, even a life-size picture of somebody's cat—that make it reminiscent of works by Renoir and Toulouse-Lautrec.

FRANK EUGENE

Frau Ludwig von Hohlwein, c. 1910

How far "Camera Work" (and Stieglitz's taste) had come from the soft romanticism of Gertrude Käsebier was revealed in the light and shade patterns that Strand abstracted from such ordinary scenes as this Port Kent, New York, barnyard. "Look at the things around you, the immediate world around you," he urged his fellow photographers. "If you are alive it will mean something to you, and if you care enough about photography, and if you know how to use it, you will want to photograph that meaningness."

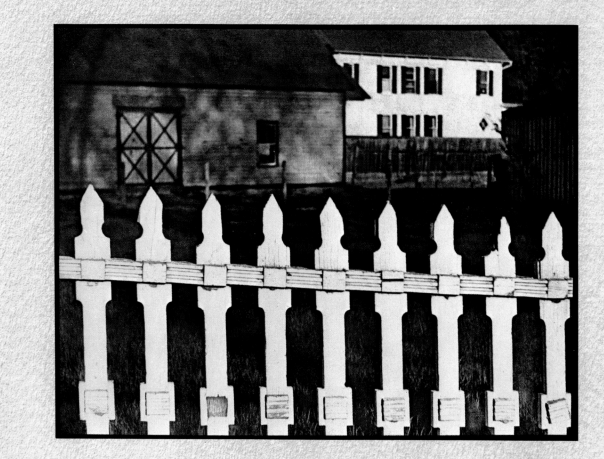

PAUL STRAND

The White Fence, 1916

How to Develop the Negative

2

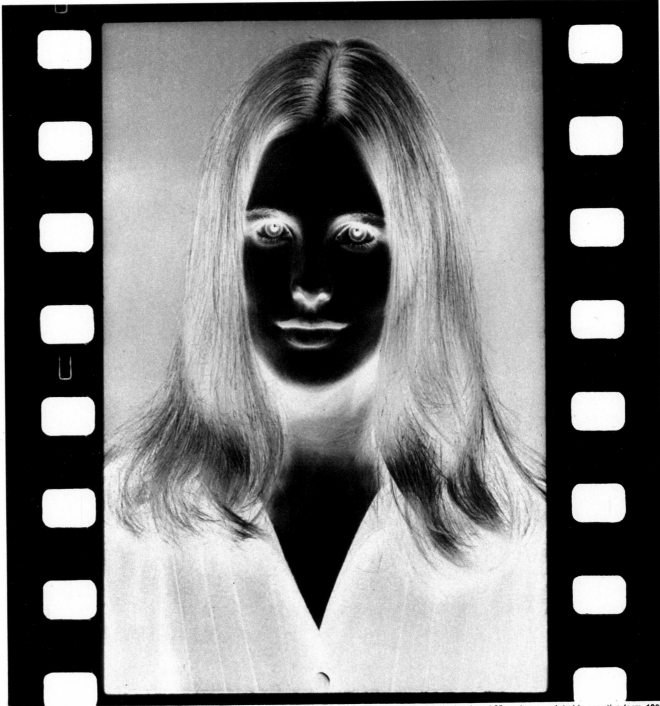

EVELYN HOFER: *A fully developed 35mm frame, printed in negative form,* 1969

The Art of Developing Good Negatives

In one sense, the moment the camera shutter clicks the picture has been made. Yet nothing shows on the film: the image is there but it is transient, reversed—and invisible. Not until it has been brought out by development and then printed is the picture there to be enjoyed. How enjoyable it will be depends to a great extent on how these steps are carried out. For they provide the photographer who processes his own pictures with unparalleled opportunities to control the results.

This control begins with the development of the negative. The techniques are simple, and using them to govern the quality of the picture may mean nothing more than exercising care to get crisp detail and to keep off dust spots, stains and scratches. Control at the next level means adjusting the developing process to suit individual taste: for example, to produce especially fine grain in the image so that a precise detail will show clearly in an enlargement, or to make pictures a bit lighter or darker than average. Finally, control affords an opportunity, by the use of special chemicals and techniques, to salvage negatives that were wrongly exposed and to rectify mistakes in developing.

At every level, such control aims to reproduce the original scene (or the photographer's vision of it) by manipulating two basic characteristics of the negative: density and contrast. Density is simply the degree of darkness of the negative image. It depends on the amount of black metallic silver in the image. A dense, dark, negative is one that is generally heavy with silver (its opposite, a "thin" negative, has little silver and looks pale). The image is formed by differences in density—the contrast between one tone and another. Density and contrast together build up the detail of an image, and they determine whether it will be crisp or indistinct, grainy or smooth.

A number of factors effect this image-molding process. The developer itself, a complicated solution containing several chemicals, is the active molder of the image *(pages 66-67)*. But equally important are the final steps of the process. The stop bath must apply a chemical brake to halt development quickly; the fixer must dissolve leftover emulsion crystals lest they too darken *(pages 68-69);* and finally, clean water must wash away chemicals that might injure the image *(pages 70-71)*.

The actions of all these substances depend on their temperatures *(pages 76-77)* and on how long they are permitted to work on the film *(pages 74-75)* —seemingly minor variations from recommended conditions have a strong influence on contrast and density. Time is easily controlled with timers. Temperature regulation requires more attention. All solutions must be kept at a standard temperature—usually 68° F.—by standing the bottles in a pan of 68° water. Even the tank or tray for developing film is warmed or cooled as necessary before use, and in use it rests in a tray of 68° water.

The standard conditions should be adhered to rigidly for the routine processing of most negatives. The pictures on pages 58-64 show step by step the normal procedure for handling the roll films used by most amateurs. The processing of sheet films follows the same steps but can be carried out in open trays—much like the processing of prints *(Chapter 3)*—or in special tanks. But these routine procedures may have to be altered to achieve complete control over negative quality. This calls for an understanding of the role played by each factor involved—exactly how and why contrast, density and other characteristics of the negative are influenced by developer, stop bath, fixer, washing, time and temperature. Their effects are described in the second part of this chapter *(pages 65-84).*

The skills needed to develop good negatives are quickly learned, and the equipment demanded is modest. Most amateurs get along with temporary work areas in kitchen or bathroom—a sink with running water is a necessity for washing negatives (and prints) and a convenience during other steps. If a kitchen is used as a part-time darkroom, particular care must be taken with photographic chemicals. They, like many ordinary household supplies, are potent substances; many stain flooring and textiles, some may cause skin irritations and a few are poisonous.

The word darkroom is something of a misnomer, for most steps in processing do not call for total darkness. Bright room lights can be left on most of the time during the development of film (printmaking is carried out in the illumination of a "safelight," which emits light of a color that does not affect printing paper). Total darkness is required, however, while film is being taken off its camera spool and loaded into the developing tank. During those five or ten minutes, not even a glimmer of light can be tolerated; even a work area that *seems* pitch dark may still be unsafe for unshielded film.

If there is any doubt about the risk of light, it is wise to make a darkness test. Clip off a few inches of unexposed film and lay it on the work surface, making sure the emulsion (the side of the film that feels smooth but not glassy) is facing up. Cover half the film with a piece of cardboard and leave it there for about 15 minutes. Then process the film clip as if it were an entire roll *(pages 56-64).* After processing, examine the film closely. If it is uniformly blank the work area is safe to use. But if a tinge of gray distinguishes the half that was not shielded by cardboard, the work area is not dark enough.

Total darkness is difficult to attain during daylight hours unless special tight-fitting shutters are made for windows (ordinary shades cannot block all light). Even at night, windows should be shaded against light from the street. A closet, however, serves well for film handling; once the film is loaded into the tank and the tank closed up, the remaining steps of development can be carried out in ordinary room illumination. □

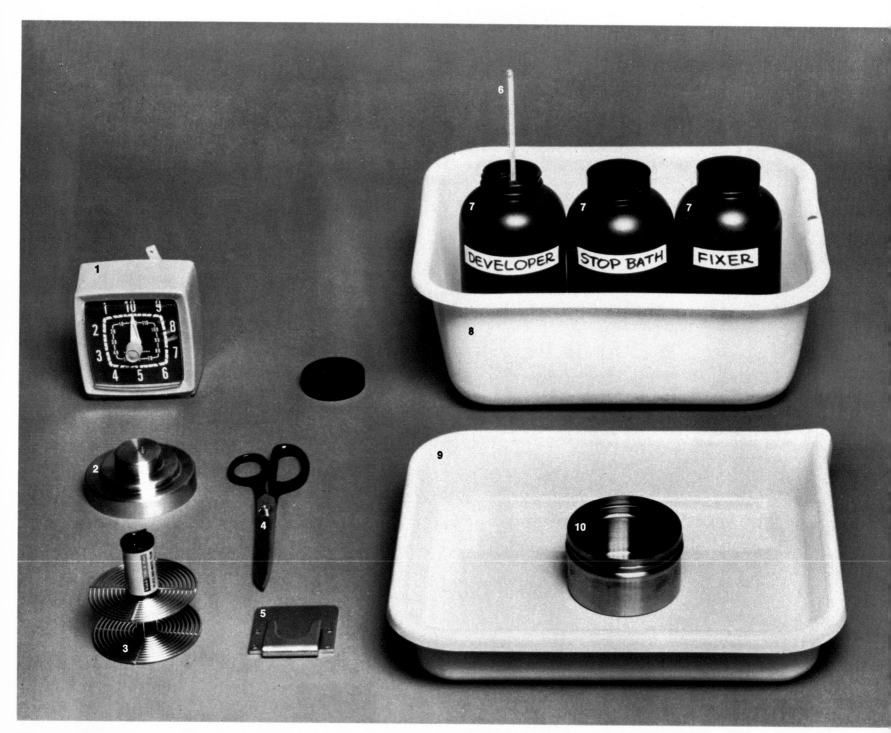

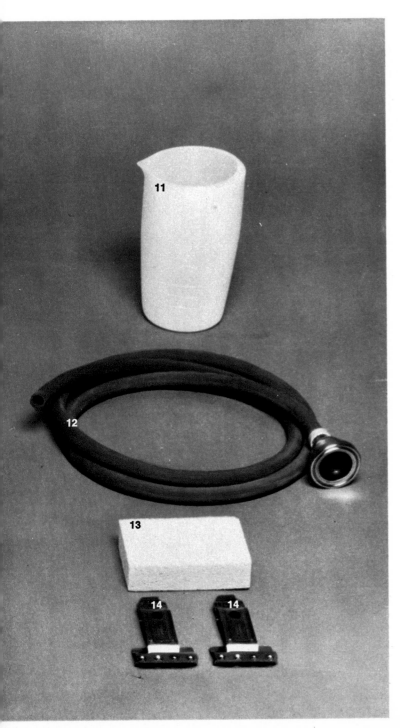

1 | interval timer

2 | developing tank cover

3 | developing reel

4 | scissors

5 | film cassette opener

6 | thermometer

7 | chemical solutions

8 | temperature control pan

9 | temperature control tray

10 | developing tank

11 | one-quart graduate

12 | washing hose

13 | viscose sponge

14 | film drying clips

Most items needed to develop roll film are inexpensive, but it is wise not to skimp on the developing tank (the one shown is designed for 35mm film; other models will accommodate all sizes of roll film). The specialized timer is a great convenience, but an inexpensive kitchen timer will serve. Any sort of dark bottles can be used for the solutions, so long as they pour easily, have tight-fitting caps and are carefully cleaned. Some of the equipment, such as the graduate, tray and washing hose, can be used later in making prints.

What is essential is an orderly and convenient arrangement of the equipment. Development will begin in total darkness and the rest of the process, once begun, moves briskly. Even before laying out the equipment, make sure that the chemicals needed are ready. Most of the commonly used developers come in powder form. Follow the manufacturer's mixing directions exactly. Buy the stop bath as a concentrated liquid and dilute it for use. Buy fixer also in concentrated liquid form, at least to start (it is cheaper as a powder but the convenience of the liquid makes up for extra cost).

After mixing and diluting each solution adjust the temperature to 68° F. *(step 1, page 58),* and place the bottle in the temperature control pan with water at 68°. Fill the empty developer tank with 68° water and place it in the temperature control tray with water at 68°. A variation of even a degree or two in developer may make a difference *(pages 76-77).* Only after the basic developing procedure has been mastered should the rigid time and temperature stipulations be varied to achieve special results *(pages 80-83).*

Preparing Chemicals and Film

1 | adjust the temperature

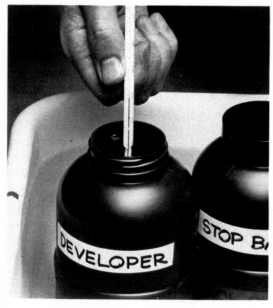

Make a temperature check of the three solutions (rinse the thermometer each time). All of them should be at 68° F.—which is just about where they will stay normally in the average house. To adjust a solution that is not right on the dot, hold the bottle under a faucet of hot or cold running water. Leave the thermometer in and watch it carefully as the temperature changes (but be sure that the water does not splatter into the bottle). Once the solutions themselves are right, recheck the water in the temperature control bath, the developer tank and its temperature control tray, adding hot or cold water to stabilize it at 68° during the entire period.

2 | fill the tank with developer

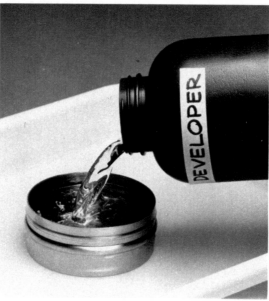

After emptying the tank of the 68° water that was used to stabilize its temperature, pour in the developer. Fill the tank almost full. Recap the developer bottle and replace it in the pan. (If the working area ordinarily used cannot be made absolutely dark—see page 55 for a total darkness test—handle the film in a closet and delay until later the tank filling step. In this case, load the film on the developing reel—steps 4 through 7—place the reel in the unfilled tank and put the light-tight cover on the tank. This shields the film from light and it can be taken to the regular working area. There, fill the tank with developer, pouring the solution through the special pouring opening in the tank cover.)

3 | set the timer

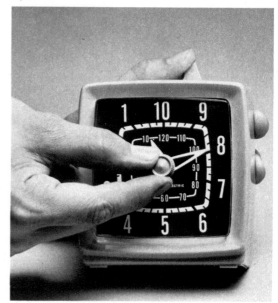

The interval timer is set—but not started—in advance of development (when following the standard development procedure), for actual development of the film begins while the room is in total darkness. Development times for various brands of film are listed in a chart for "small-tank development" in the instructions that come with the developer. Or use the developing instructions that come with the film. Follow the recommended time closely or the negatives will be too thin and flat or too dense and harsh (pages 74-75). If you are using an ordinary kitchen timer that has no separate starting lever, put several thicknesses of tape on the dial opposite the correct development time. By feeling for the tape you will be able to turn the pointer to the right spot in the dark.

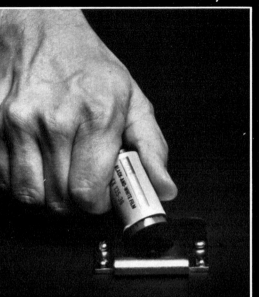

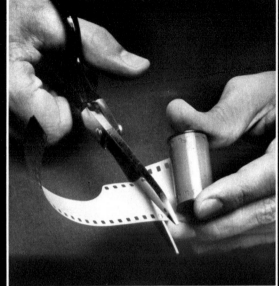

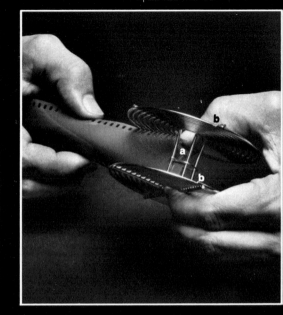

With all lights turned off, open the roll of film. To remove film from a standard 35mm cassette, find the spool end protruding from one end of the cassette. Pick up the cassette by this end, then pry off the other end with the cassette opener or a soda-bottle opener. Slide the spool out. Larger sizes of roll film are not contained in cassettes; with one of these, simply break the paper seal, unwind the roll a bit and free the film from its paper backing. To open a plastic cartridge used in an instant loading camera, twist the cartridge apart and remove the spool. Be sure that the film loading area is totally dark (page 55). Then take one more precaution. Lock or block the door. Many a film has been ruined by Junior inadvertently bursting in at the wrong moment.

With the scissors, cut off the protruding end of the film to square it off. Do not try to tear the film; besides injuring the emulsion the friction of tearing could cause a flash of static electricity —a tiny bit of light but enough to streak the film. Keep the scissors handy—they will be needed again in a moment—but put them where the blades or points cannot scratch the film.

Hold the spool in either hand so that the film unwinds off the top. Unwind about three inches and bow it slightly between thumb and forefinger. The reel must be oriented properly in the other hand or the film will not slip into the grooves. Each side of the type shown is made of wire in a spiral starting at the core of the reel (marked "a" in this picture) and running to the outside; the space between the spirals of wire forms the groove that holds the film edge. Hold the reel so that the sides are vertical and feel for the blunt ends (b) of the spirals. Rotate the reel until the ends are at the top. If the ends then face the film the orientation is correct. Now insert the squared-off end of the film into the core of the reel. Now rotate the reel away from the film to start the film into the innermost spiral groove. Practice this and the next step with a junked roll of film until you can perform both of these steps smoothly with eyes shut.

Getting the Film into the Developer

7 | wind the film on the reel

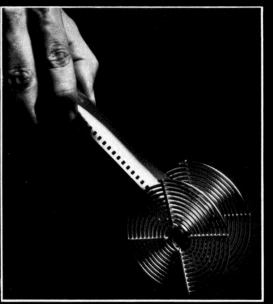

To finish threading the reel, place it edgewise on a flat surface. Continue to hold the film spool as before, with thumb and forefinger bowing the film just enough to let it slide onto the reel without scraping the edges. Now unwind three or four inches of film and push the film so that the reel rolls forward. As it rolls it will draw the film easily into the grooves. When all the film is wound on the reel, cut the spool free with the scissors. Check that the film has been wound into an open spiral, each coil in its groove. Determine—with a junked roll—how your film should fit on your reel. If, after loading, you find more—or fewer—empty grooves than the length of your film allows for, pull the film out, rolling it up as it comes, then reload the reel. Unless the reel is correctly loaded, sections of film may touch, stopping development at those points.

8 | put the reel into the tank

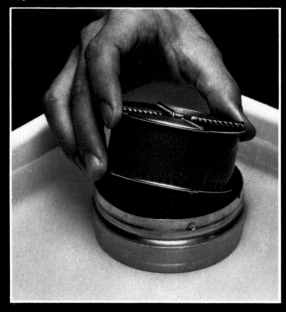

Now actual development can begin and you must do two things at once. With one hand drop the loaded reel gently into the developer in the tank. Simultaneously, with the other hand feel for the starting lever of the timer (you are still in total darkness). As the reel touches the bottom of the tank, start the timer. Put a finger in the core of the reel and joggle the reel up and down several times, gently but firmly, to dislodge any air bubbles that might be clinging to the film.

9 | cover the tank

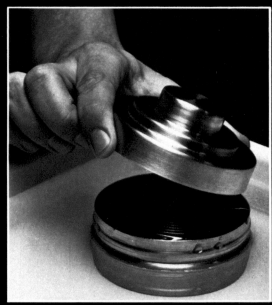

Put the light-tight cover on the developing tank. Lift it out of the temperature control bath immediately, and tap the bottom of the tank lightly on a hard surface. This will dislodge air bubbles and keep them from transferring to the film. Now the room lights may be turned on.

10 | agitate

11 | remove the cap from the pouring opening

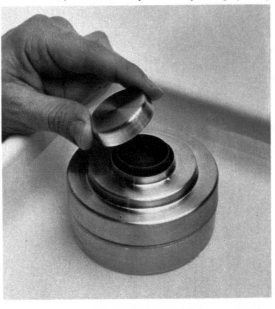

12 | pour the developer back

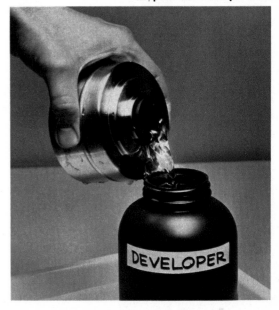

As soon as the lights are on, agitate the tank, using the motion shown in the multiple-exposure photograph above; turn it back and forth through a 45° arc, as if turning a key in a lock. This is an essential part of the developing process because it keeps bringing fresh portions of the developer solution into contact with the film emulsion (pages 78-79). Agitate 15 seconds once each minute during the developing period, leaving the tank in the temperature control bath between agitations.

About 30 seconds before development is completed, get ready to empty the developer from the tank. Remove the cap from the center pouring opening—BUT DO NOT REMOVE THE TANK COVER ITSELF. Pick up the bottle containing the developing solution, set it in the tray near the tank and unscrew its cap.

The instant the timer signals that development is completed, start pouring the developer from the tank into the bottle. If the bottle has a small mouth, or if the tank does not pour out smoothly, use a funnel to speed pouring. As soon as the tank is empty set it back in the tray. Recap the developer bottle and open the stop-bath bottle.

Preserving the Developed Negatives

13 | fill the tank with stop bath

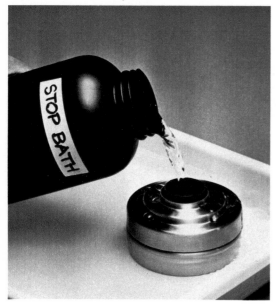

Quickly pour stop bath into the tank through the center pouring opening of the cover. *DO NOT REMOVE THE TANK COVER. Fill the tank just to overflowing to make sure the film is entirely covered. On some tanks the light baffle in the opening is arranged so that the tank must be held at a slight angle to facilitate pouring.*

14 | agitate

After replacing the pouring opening cap, agitate the tank gently for about 15 seconds.

15 | pour back the stop bath

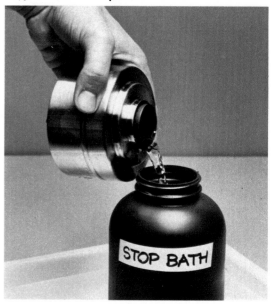

Empty the tank of stop bath. *DO NOT REMOVE THE TANK COVER. Some photographers throw out used stop bath, since it is inexpensive and easier to store as a concentrated solution.*

16 | fill the tank with fixer

17 | set the timer

18 | agitate

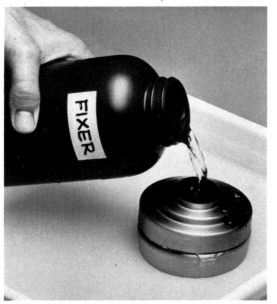

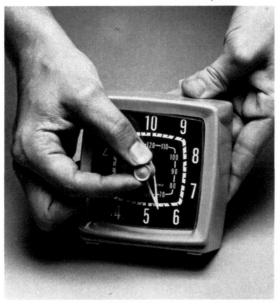

With the tank cover still on, pour fixer through the pouring opening in the cover. Fill to overflowing. If the workroom is very hot or cold it is a good idea to recheck the temperature of the fixer before filling the tank. Make sure it is within two or three degrees of 68°; if its temperature must be corrected, fill the developing tank temporarily (without removing the cover) with water at 68°. When the temperature of the fixer is properly adjusted, empty the tank of water and fill it with fixer.

Turn the timer pointer to the optimum fixing time recommended in the chemical manufacturer's instructions. If minimum and maximum times are given, use the longer time, or close to it; too short a fixing period may make the image subject to fading (pages 68-69). Be sure to use the figures specified for films; most fixing solutions can also be used to process prints, but the dilutions and times required are different.

Agitate the fixer-filled tank as described in step 10. When the timer signals that the period is up, pour the fixer back into its container. The entire cover of the tank may now be removed, since the film is no longer sensitive to light.

Washing, Drying and Keeping Records

19 | wash the film

With the faucets adjusted to provide running water at 68°, insert the hose from the tap into the core of the reel. The reel should be left inside the open tank in the sink. Let the water run rather slowly; too much force can damage the film emulsion, for it is relatively soft when soaked with water. About 30 minutes' washing is needed to prevent later deterioration or discoloration of the image (see pages 70-71).

20 | dry the film

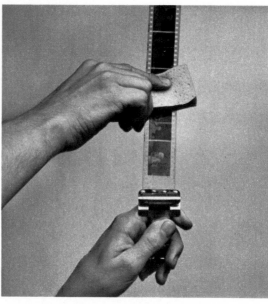

Now the film can be unwound from the reel for drying and you get a chance to look at your negatives. Unwind gently; the emulsion is still wet and soft, and easily scratched. Attach a clip to one end of the film and hang it in a dust-free place where the room temperature will remain constant during the drying period—one or two hours at least. The middle of a room, away from walls and windows, is best since it is usually less plagued by dust and temperature fluctuations. Attach a weighted clip to the bottom of the film. Pull the film taut and remove excess water from the surface by gently drawing a damp, non-scratchy viscose sponge, held at a 45° angle, down both sides of the strip of film.

21 | record the work done

Write down the number of rolls developed on a label affixed to the developer bottle. The instructions that came with the developer tell how many rolls may be processed in a given amount of solution and how to alter the procedure as it is re-used. Each succeeding roll of film requires either an extension of developing time or, with some developers, addition of a "replenisher". Also record the date the developer was first mixed, because even with replenishing most developers deteriorate as time passes (pages 72-73). Keep the same usage records for stop bath and fixer.

Development Problems and How to Avoid Them

Developing negatives strictly by the book would always turn out good pictures—except that the book is written for average negatives, and far-from-average ones are all too common. For them the standard procedure is not enough; they will come out too grainy, too light or too dark, too harsh or too flat. An understanding of the reasons behind the rules is needed, so that standard procedures can be modified to prevent such defects.

A photographer whose negatives consistently turn out too dark, for instance, can get lighter ones if he knows how to modify the length of development time. It is even possible, when a bad exposure is suspected, to break the cardinal rule of total darkness and, with special precautions, turn on a dim light for a look at the film; the photographer can then take remedial action while the process is still going on.

Whatever the circumstances, and whatever modifications they may call for, the photographer is almost always pursuing the same goals: normal density and contrast, and the least possible graininess (if he has different goals in mind, they are best pursued in printing, not in negative development). There are several ways to achieve these three goals, and nearly all are interrelated.

Density, which is a measure of how dark the image gets, is influenced most readily by time—the length of time the film is in the developer. More time gives a darker negative, less time a lighter negative. Density can also be changed by altering the temperature of the developer solution, although this method of control is less common than changing the time. Another factor that influences density is the amount of agitation the film receives during development. However, it is not varied to control density, as time and temperature are, but is kept constant to guarantee that development continues at a steady pace so all parts of the film are affected equally.

Contrast, being a product of the way density varies in different parts of the negative, is influenced by the same factors that affect density itself. Any modification that increases the density usually increases contrast. Also, graininess is closely related to contrast—the more contrast the more grain—and is altered in much the same ways.

Another dimension of control over negative quality is provided by the choice of developer. Normal developers work deliberately to create even gradations of gray tones—that is, even contrast—with moderate graininess in all parts of the negative. But there are "high-speed" developers that quickly build up density and contrast (and graininess), greatly reducing developing time. "High-energy" developers compensate for underexposure by concentrating on the highlights. Fine-grain developers turn out negatives that produce big, sharply detailed enlargements. And still other developers are made to increase or decrease contrast.

Since so many of the factors that influence the negative are interrelated, the photographer will find many ways, as he becomes more familiar with the development process, of adjusting procedures to fit his particular needs. There is a limit, of course, to how much modification the rules will stand. The aim should be to change them only when necessary, and then only as much as is necessary, to make each negative as nearly normal as possible.

How Developer Chemicals Affect a Picture

A working acquaintance with developers—with their ingredients, capabilities, limitations—is useful insurance against bad negatives. Such understanding helps the photographer know what to expect of a given formulation, how to alter those results if need be, and how to choose, from dozens on the market, one to suit his taste.

The most important ingredient in any developer formula is the developing agent. Its job is to free metallic silver from the emulsion's crystals so it can form the image. These crystals contain silver atoms combined with bromine atoms in the light-sensitive compound silver bromide. When struck by light during an exposure, the silver bromide crystals undergo a partial chemical change. The exposed crystals (forming the latent image) provide the developing agent with a ready-made working site. It cracks the exposed crystals into their components: metallic silver, which stays to form the dark parts of the image (*see pictures at the right*), and bromine, which unites chemically with the developer.

Some developing agents are used alone, but often two together have complementary properties, as can be seen in the pictures of a bathtub in the top row on the opposite page. One combination is made of the compounds Metol and hydroquinone. If hydroquinone is omitted from the usual formula, the result is a loss of contrast (*opposite, top center*) as compared to a normal negative (*top left*). If there is no Metol in the compound, the image may fail to appear during the usual developing period (*top right*).

When developing begins, the action is sluggish, so an "accelerator" is added; without it a negative comes out underdeveloped (*opposite, bottom left*). Once started, though, the process goes so fast that unexposed areas are developed unless a "restrainer" is included; without it a negative is overdeveloped (*bottom center*). Finally the developers deteriorate in air, and they release by-products that weaken their action and may discolor the negative (*bottom right*)—unless a "preservative" is added.

For normally exposed films of moderate or high speed, the best developer is one that will give normal contrast with moderate grain. Examples of these are Kodak D-76, Ilford ID-11 and Ethol TEC. Finer grain can be obtained—but usually with some loss of contrast and film speed—with such developers as Kodak Microdol-X, Ilford Microphen or Edwal Super 20.

Electron microscope pictures of four emulsions show how exposed crystals of silver bromide (magnified 5,000 times) are converted to pure silver during development. At first (top) the crystals show no activity (dark specks on some crystals are caused by the microscope procedure). After 10 seconds parts of two small clusters (arrows) have been converted to dark silver. After a minute, about half the crystals are developed, forming strands of silver. In the bottom picture all exposed crystals are developed; undeveloped crystals have been removed by fixer solution and the strands now form the grain of the finished negative.

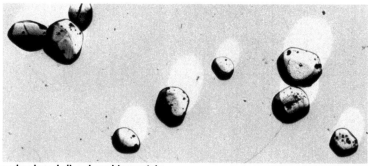

undeveloped silver bromide crystals

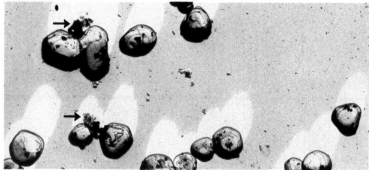

developed 10 seconds

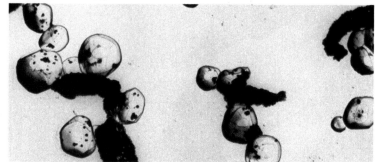

developed 1 minute

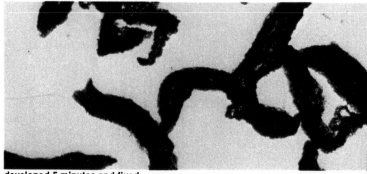

developed 5 minutes and fixed

normally developed negative

negative developed without hydroquinone

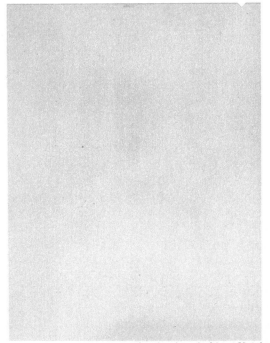

negative developed without Metol

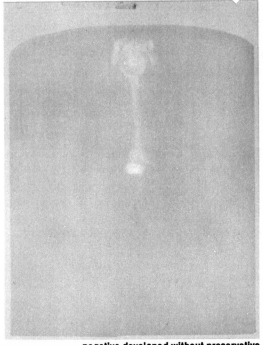

negative developed without accelerator

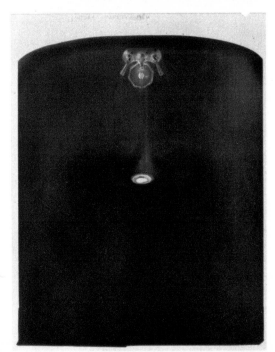

negative developed without restrainer

negative developed without preservative

What Fixer Does

too little fixer

normal negative

After the developer has done its work the image on the negative is visible but very perishable. If exposed to light it vanishes into total blackness. To prevent this, the fixer sets the image permanently on the film and prepares it for printing—if it is used properly.

The fixing agent is needed because the negative image is surrounded by the leftover crystals of silver bromide; since they represent shadows in the scene, they were not exposed and they should not be converted to dark metallic silver. But, if allowed to remain, these leftover crystals will darken in the light and black out almost the entire image *(above, left)*. The fixer prevents this by getting rid of the unneeded crystals. It dissolves them out of the emulsion.

Finding the right solvent to accomplish this took a third of a century and was a major stumbling block in the early evolution of photography. The man who solved the problem was Sir John Frederick Herschel, the famous English astronomer and an early photographic chemist. In 1839 he suggested using sodium thiosulfate, and no better fixer for general use has yet been found. (For a long time photographers thought they were using sodium hyposulfate, and hypo is still a common name for fixer.)

One other important substance, although not technically part of the fixing operation, is added to the solution. This is the hardener compound, usually po-

too much fixer

tassium alum, which prevents the film emulsion from becoming so soft or swollen that it is damaged during the washing that follows fixing.

Under normal conditions the fixer dissolves only the unexposed crystals of silver bromide and does not affect the metallic silver making up the image itself. But if the film is left too long in the fixer a side reaction converts the silver into a compound that will, in time, cause the image to dissolve *(above,*

right). This upper limit to the fixing period is quite long—about three times the recommended maximum.

Ordinarily the danger is not too much fixing but too little. If the fixer is not given sufficient time to complete its work, silver bromide crystals are left undissolved and they later darken. Often, the fault is simply repeated use of the same solution: a given amount of fixer can dissolve only so much silver bromide. Then it stops working.

Reticulation's Crinkled Image

Perhaps the most bizarre affliction that can strike the negative during development is an effect called reticulation, a crinkling of the entire gelatin emulsion, as shown above. It occurs when the negative is abruptly moved from a very warm solution, which softens and expands the gelatin, into a very cool solution, which hardens and shrivels it up. The crinkling is so evenly textured (inset) that reticulation is sometimes done on purpose for an artistic effect. But once done it cannot be undone, and in regular work, especially with miniature images that must be greatly enlarged, reticulation is disastrous. It can be avoided by keeping all solutions, from developer to washing bath, at or very near the same temperature.

"Pushing" Film Speed

	normal development [1]	to double film speed [2]	to triple film speed [2]	to quadruple film speed [2]
Agfa Isopan Ultra (ASA 400)	Atomal, 11 min. at 68°	Atomal, 16½ min. at 68°		
GAF Super Hypan (ASA 500)	Hyfinol, 8 min. at 68°	Hyfinol, 12 min. at 68°	Acufine, 8 min. at 75°	Acufine, 11 min. at 75°
Ilford HP 4 (ASA 400)	Microphen, 5¾ min. at 68°	Microphen, 8½ min. at 68°	Ethol UFG, 4 min. at 68°	Ethol UFG, 6 min. at 68°
Kodak Tri-X (ASA 400)	D-76, 8 min. at 68°	D-76, 12 min. at 68°	D-76, 9¾ min. at 75° or HC-110(A), 6½ min. at 68°	D-76, 13 min. at 75° or HC-110(A), 8 min. at 68°

[1] Specifications for normal development are manufacturers' recommendations.
[2] Specifications for developing films exposed at higher ASA ratings are suggestions only; for best results make your own tests.

When taking pictures in poor light, many photographers deliberately underexpose the film —that is, they assume its ASA rating is double or even triple the normal rating—and then compensate by giving it special treatment during development. This practice is called "pushing." It may be accomplished in any of three ways, as this chart shows: by increasing development time in a normal developer; by increasing temperature in a normal developer; or by switching to a high-energy developer. The three measures are not interchangeable, but are used as increasingly powerful development activity is needed. When the ASA rating has been pushed to twice normal (from 400 to 800), for instance, it is preferable to use normal developer and merely extend the time of development. When the ASA is more than doubled, one of the other methods is preferable. The same restriction applies in reverse: a high-energy developer such as Acufine, for instance, should not be used except when film is being pushed. If used with normally exposed film it may produce flat and grainy negatives. Pushing film is a valuable technique, but it exacts a price. It brings up the image by increasing the density, and in doing so it increases graininess and contrast. This loss of quality is not very serious if the ASA rating is doubled. Beyond that, quality begins to fall off, and it nears the point of unacceptability if the ASA rating is quadrupled. When processing film at specifications that are other than normal ones, photographers make tests to establish their own standards.

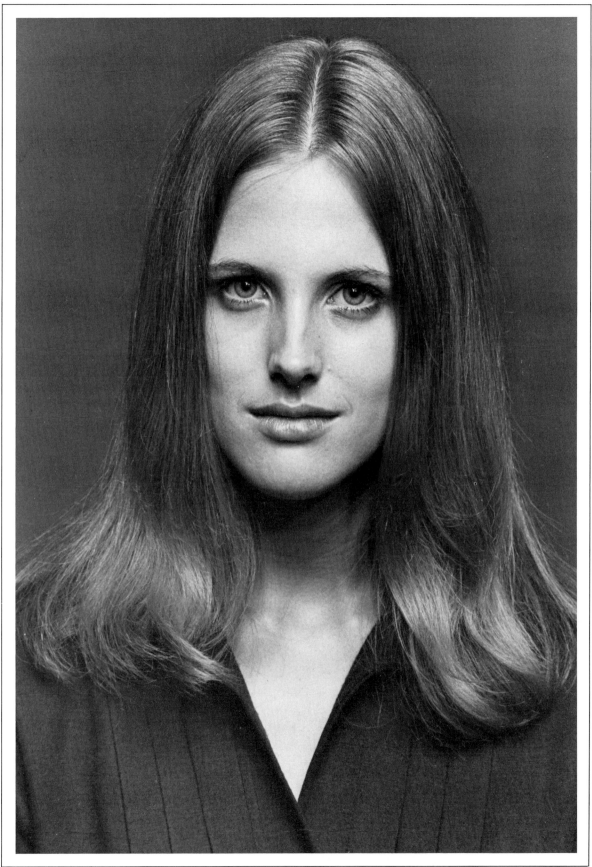

EVELYN HOFER: *Enlargement from a 35mm negative*, 1969

Photography's Goal: A Print

In printmaking, photography at last yields its prize. To many photographers, this final stage of their craft is the most pleasurable of all. The fleeting scene that was caught on film and elicited in reverse in the darkroom now—magically, it seems—swims into lifelike view. In contrast to the instantaneity of the actual picture taking and the rigid control usually required of film development, printmaking lends itself to leisurely creation. Here, under the yellowish glow of a safelight, poor negatives can be saved and ordinary pictures can be transformed into something special. Here the photographer can shape and tune his image—enlarge it, endow it with tones that are warm or cool, alter the shades of light and dark in the scene, heighten or reduce the contrast between them, cut out the unwanted portions of the picture and otherwise ready it to be mounted in the scrapbook or prepare it to be framed for hanging in the gallery.

The physical processes of printmaking essentially repeat those of the first two stages of photography: recording light on film and developing the negative. Like film, printing paper is coated with a light-sensitive emulsion containing crystals of silver atoms combined with bromine or chlorine atoms or both. Light is passed through the negative and onto the paper—either directly, when contact prints are made, or with the help of a lens, when an enlargement is made. The paper is placed in a developer for several minutes so that chemical action can convert into metallic silver those of the crystals that have been exposed to the light; it is next transferred to a chemical solution called a stop bath to halt the action of the developer, then is put in the fixer, which removes undeveloped and unexposed crystals, and finally it is washed and dried. Now at last there is a permanent positive image, its dark areas corresponding to the light areas of the negative, which were generated by the dark areas of the original scene. The view the camera saw has been reproduced in shades of gray in a picture.

In each of these steps procedures are dictated by the chemical processes involved, yet printmaking can be highly subjective. Skills of the hand and eye are crucial. For example, the proper exposure of the printing paper is usually determined visually, rather than by a light meter or some other mechanical device. The photographer tests various exposures on a single piece of printing paper and develops the paper to see which gives the best image—the one that looks the best to his eye. His final print is made at that setting. But this is only the beginning of manual and visual control in printmaking, for the photographer is able to make a particular portion of the print darker (a procedure called "burning in") or keep a portion lighter (called "dodging"). At the simplest level this is done by placing the hands between the enlarger lens and the paper in order to control the amount of light reaching various parts of the print. The method may seem crude, but it can be a very effective

one. And it is only one among the many manipulative techniques that permit the printmaker to adjust the positive image to match that of the negative—or to deviate from it.

Even the development of the print is no cut and dried operation, as it normally is with film, carried on out of sight and controlled automatically by clock and thermometer. The temperature of the print developer solution and the time allotted for the process must be held within limits recommended for the materials, it is true, but these limits are not nearly so narrow as those set for film. The development process can be watched, so that the photographer himself can decide when it has gone far enough. He sees the image forming before his eyes, appearing with tantalizing slowness at first as the shadows of the scene suggest the beginning of the picture. These darken fairly rapidly while details slowly build up in the brightest areas of the scene *(page 102)*. It takes a bit of experience to learn how to judge when development is completed. There is a great temptation to pull the print out of the developer too soon, for the picture always looks darker in the dim illumination of the safelight than it will later in ordinary room light. But a bit of practice soon brings the ability to sense the balance of tones required of a fully developed print. The shadow areas are the first clue, for they should become a rich, deep black, yet not so dark that details are obscured; at the same time the brightest areas must not turn gray but remain a clear white while still indicating their own fine details.

In every stage of printmaking, opportunities for influencing the final result exist and judgments based on artistic rather than technical considerations must be made. The choice of such basic equipment as the enlarger has an effect, for it can produce soft, gently modulated tones or crisp, sharp ones, depending on the way its optical system spreads light over the negative. The selection of enlarging papers, too, permits great creative latitude. There are literally hundreds of kinds of printing papers on the market, providing various options of texture, finish, tint and image tone. In addition, each kind of paper comes in several "grades," which determine the contrast between the tones of gray. By manipulating these factors—and influencing them through the choice of developer, which also affects the tones and the contrast—the photographer is able to control the mood and impact of his prints, emphasizing the brilliance and the detail of one picture, and giving an image warmth and softness in another.

Such choices demand a steady exercise of taste. The consequences of each decision are almost immediately visible—and a wrong choice can be easily repaired by simply making another print. Small wonder, then, that printmaking is so enjoyable, for it gives the photographer an opportunity to enhance the image that the camera saw. ☐

55 | agitate

Move the print about occasionally while it is in the fixer. Room lights can be turned on after a minute or two and the print examined.

56 | remove the print

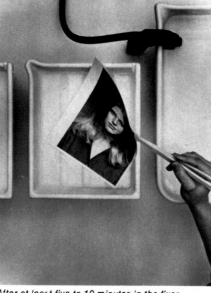

After at least five to 10 minutes in the fixer, transfer the print to the washing tray. Fix long enough or the image may fade and stain.

57 | wash

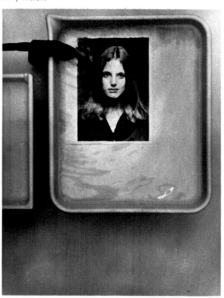

The print must be washed for at least 60 minutes in running water to remove all traces of fixing solution. If any remains, the print may yellow.

58 | remove the surface water

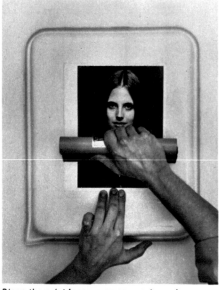

Place the print face up on an overturned tray and squeeze off most of the water. Moderate pressure will not harm the print.

59 | dry

Roll the print face down in a blotter roll and leave it to dry overnight. It will come out uncrinkled, with a very slight curve.

A Machine for Big Contact Prints

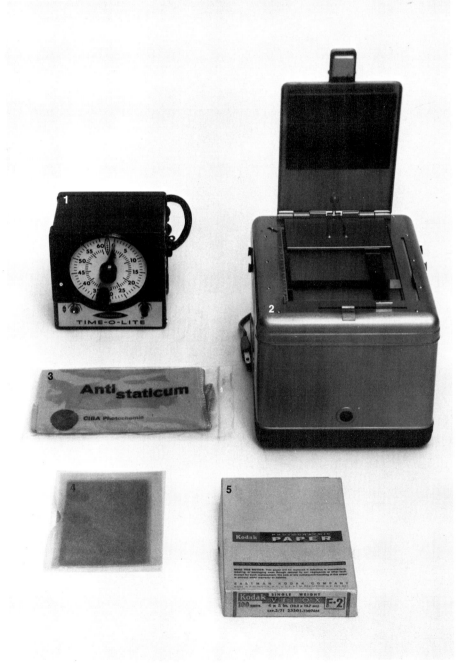

1 | **automatic timer**

2 | **printing box**

3 | **antistatic cleaning cloth**

4 | **negatives**

5 | **contact printing paper**

Photographers who employ large-size film, 4 x 5 and up, frequently make final prints as well as proof prints by the contact method. For this purpose, they generally use a special printing box with a built-in light source *(left),* which is more convenient than the simple hinged frame meant for proofs of small negatives *(pages 96-97).* They will also need the materials shown at left: antistatic cloth to clean the negative, an automatic timer to control the exposure, as well as special contact printing paper, which can range from 10 to 1,000 times less sensitive than the ordinarily used enlarging paper.

The less-sensitive paper can be used because there is so much more light available to the paper. A 25-watt bulb shines up through a pane of diffusing glass, through the negative directly onto the paper. In operation the negative is placed emulsion side up on the glass, and a sheet of contact paper is laid emulsion side down over it. The hinged lid is then closed, and its underside of felt or rubber presses the paper tightly against the negative. Trial and error determine exposure time (for economy, small sections cut from a full-size sheet of printing paper can be used in tests); two to five seconds are about right for a negative of average density. The print is processed as usual —except that contact paper needs only about 50 seconds' development.

The print box is able to print pictures much more quickly than the enlarging method, and no focusing is involved. Unfortunately, control over the printing of individual portions of the image is harder to achieve. And, of course, the final print will not be any larger than the negative is. □

Printing Paper's Palette of Gray

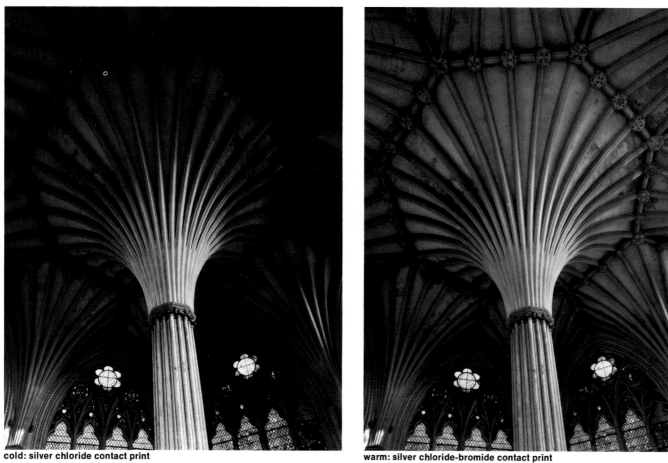

cold: silver chloride contact print

warm: silver chloride-bromide contact print

Making a black-and-white print is like painting with one color: gray metallic silver. This turns out to be a challenge rather than a limitation, for printing papers are made in such variety that shades of gray become an inexhaustible spectrum. The paper base can be manufactured in numerous textures, tones and surface finishes. And the emulsion coating can make silver images look warm or cool, sharply contrasted or softly modulated.

Even color variation is actually possible, since all gray is not simply gray,

as the pictures shown here demonstrate. The appearance of the silver may be neutral black, blue-black, warm black, brownish, even reddish. These variations in tone reflect the size and structure of the developed silver grains.

The coldest tones are generally produced by an emulsion composed almost entirely of either silver chloride or silver bromide. The interior of Wells Cathedral by Dmitri Kessel *(above left)* was printed on silver chloride paper. If silver bromide is added, the tones become warmer *(above right),* and can

even acquire brown or reddish tinges.

Emulsions in which silver chloride predominates are not very sensitive and are mainly used for contact printing. To register the dimmer image projected by an enlarger, the emulsion generally needs the more sensitive silver bromide. The enlargement of Wells Cathedral by Dmitri Kessel *(opposite, far right)* has a warm tone because the crystals in the emulsion included some silver bromide. With mainly silver bromide paper, though, the tone again becomes black *(opposite, near right).*

cold: silver bromide enlargement

warm: silver chloride-bromide enlargement

107

Moody Tints and Surface Brilliance

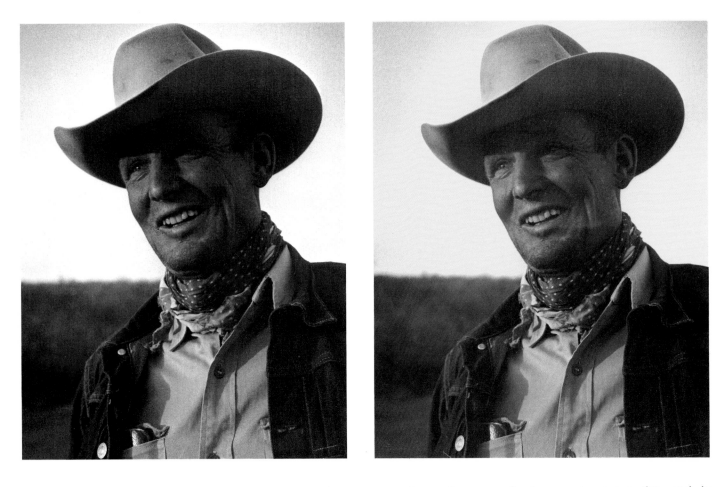

How the tint of paper affects the mood of a picture can be seen in these prints of a Texas cowboy, made from a negative shot by Leonard McCombe. The white tint of the print at left looks cold, but the other picture, reproduced with its warmer, ivory tint, gives the cowboy a romantic, almost ageless appearance.

The printmaker can suggest warmth or coolness not only by his choice of printing emulsion but also through the variety of colors, textures and sheens in which the paper itself is manufactured. The range of colors, or tints, extends from the purest white to the richest off white, encompassing shades that are usually referred to as "white," "cream" and "ivory."

White is most widely used, but is perhaps best suited to outdoor photography—such as winter scenes or seascapes—or for such inherently cold subjects as machines. Cream is an ex-

cellent general-purpose tint, and is especially popular for portraits. Ivory lends great warmth that can enhance a picture of a sunset, or one of people sitting around a fire, or a portrait. Since tints—and many of the other properties of papers—vary from manufacturer to manufacturer, most photographers experiment with several brands of paper until a suitable one is found, and then stick with it.

The surface qualities of a paper are no less important than tint in creating a print that does justice to its subject. The term "surface" actually refers to

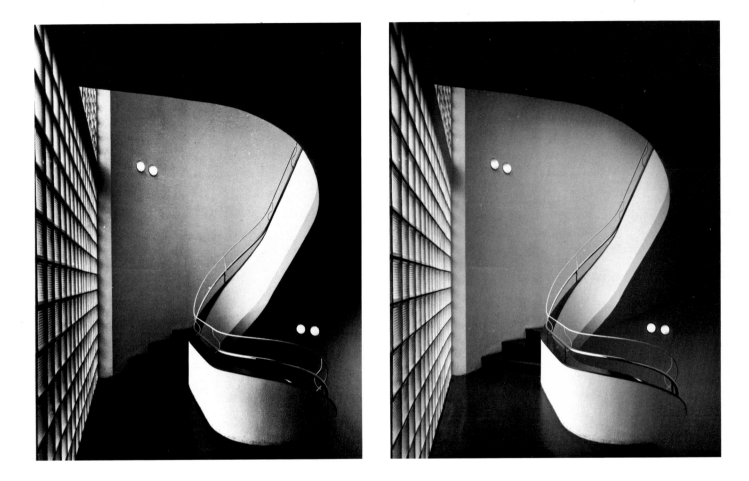

two properties—texture and finish. Both influence the amount of light that is reflected from a print. Textures are generally categorized as "smooth," "fine-grained" or "rough" (there are also specialized surfaces that resemble such fabrics as silk, tweed and suede). Finish (or "brilliance," as it is sometimes called) refers to shininess and is distinct from texture (smooth papers, for example, are made in several degrees of shininess). Some commonly available finishes are "glossy," high luster, luster and "matte." Extra glossiness (needed for pictures to be repro-

duced in a newspaper or magazine) is obtained by pressing a wet print onto a chromed metal sheet.

A very smooth surface (in terms of both texture and finish) looks bright because it reflects most of the light falling on it. In addition, it reveals maximum detail. The rougher surfaces scatter the light and obscure detail; the scattering effect not only dims the highlights, but also makes the black parts of the picture look grayish. However, such surfaces are less harsh than smooth ones, and often add atmosphere to pictures in which precise detail is not important.

The difference between matte and glossy surfaces is revealed in two prints of the interior of a modern building in Germany, photographed by Dmitri Kessel. The picture at right, above, reproduced to show a matte effect, scatters reflected light and produces less-dense blacks in the stair steps than the glossy print next to it.

Papers That Modulate Contrast

One of the most crucial characteristics of a photograph is also the simplest to control through the choice of printing paper. This is contrast, the difference in shade between one tone and a slightly darker or lighter one. Tonal differences can be exaggerated by the response of the paper emulsion to make the print more contrasty than the negative, or they can be diminished to make the print less contrasty. Most papers are made in numerical grades of contrastiness ranging from 0 (very "soft," or low contrast) through 2 (normal) to 6 (very "hard," or extremely high contrast).

The paper grade exerts a powerful influence on the appearance of a picture, as the series of photographs on the opposite page demonstrates. It can create an image that has a gentle sweep of tones, the shades of gray delicately distinguished one from another. At the other extreme, it can virtually eliminate gradations in shade, leaving an image composed almost entirely of dazzling whites and opaque blacks.

Contrast is affected not only by the print emulsion but by numerous factors throughout the photographic process —the lighting of the scene, exposure, type of film, development of the film and print, even by the kind of enlarger used. Furthermore, contrast as a characteristic cannot be entirely separated from another key property of a photograph: the number of distinct shades of gray. Contrasty paper, by increasing the difference between tones, eliminates subtle variations in tone; with fewer variations visible, fewer separate tones can be seen. At the same time, the loss of the slight variations emphasizes extremes of tone. In this way high-contrast paper may be used to produce whites and blacks that add "snap" to a dull negative. Conversely, low-contrast paper can reproduce more of the tonal variations existing in the negative, increasing the number of distinct shades. This does not eliminate extreme tones if they exist in the negative, but neither does it emphasize them.

The choice of contrast grade is often dictated by the subject of the picture. Portraits may be best served by a low-number grade, for the subtle gradations of gray produced on such paper cause shadings to indicate facial contours very pleasantly and make wrinkles and lines less conspicuous. A picture with striking geometrical design generally calls for high contrast. And increased contrast, by sharpening distinctions in tone, may make detail stand out.

Most often the choice of a grade of paper is dictated by contrast deficiencies in the negative. The paper may be selected to add lifelike sparkle to a picture that had to be shot in dull light; to correct imbalances introduced by underexposure or overexposure; or to soften harsh shadows and highlights.

grade 1 printing paper

grade 2 printing paper

grade 3 printing paper

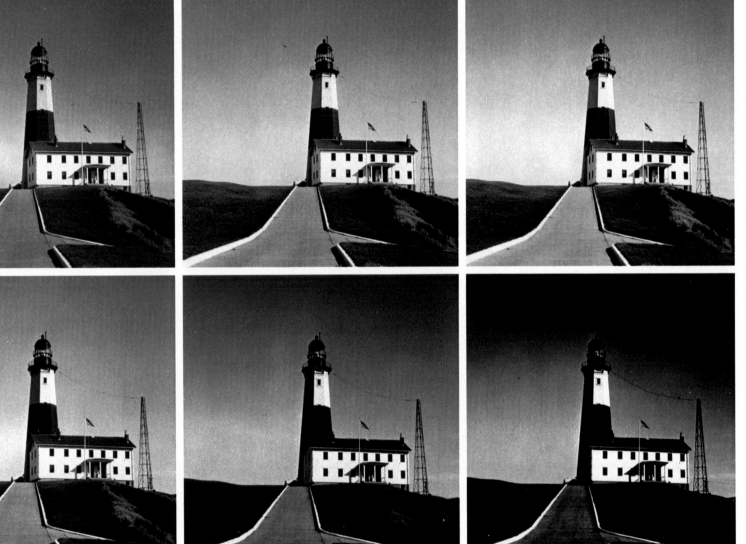

grade 4 printing paper

grade 5 printing paper

grade 6 printing paper

The Montauk Point, Long Island, lighthouse, photographed by Jules Zalon, is shown in six degrees of contrast. On grade 1 paper the long range of gray shades in the picture make it look flat, but fine tonal gradations in the grass show up. With grade 6, the pale porch shadow and the dark shadow of the window it overlaps are almost indistinguishable, and the print is almost wholly dense blacks and glaring whites.

The Versatility of Variable Contrast Paper

number 1 filter | **number 1½ filter** | **number 2 filter** | **number 2½ filter**

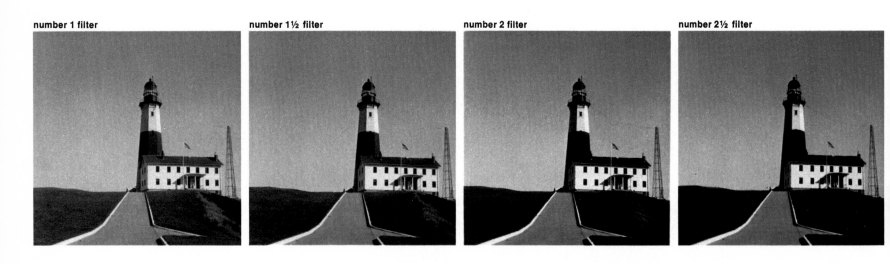

Instead of stocking a number of different contrast grades, many photographers today prefer to use a single type of paper that has adjustable contrast. Most such papers are coated with two emulsions. One, sensitive to yellow-green light, yields low contrast; the other, sensitive to blue-violet light, produces high contrast. The degree of contrast is varied simply by inserting appropriately colored filters in the enlarger *(far right)*. The filter governs the color of the light that reaches the printing paper—and thus controls contrast.

With only one type of paper and a set of filters, the photographer can attain finer gradations of contrast than might be possible with papers of different contrast grades. Furthermore, he can control the contrast of localized sections of the image. This is done by masking the paper so that the sections can be printed separately, each with the contrast filter its tones call for. A low-contrast part of the image, for example, could be enlivened by printing it with blue-violet light; a harsh part could be softened by printing in yellow-green.

The three versions at right of a Manchester, New Hampshire, mill show how several degrees of contrast in one print can improve a picture. In the version made with a number 3 filter (upper right), the contrast of water and sky seems too washed out and lacking in detail; in the version made with a number 1 filter (bottom right), the mill is too dark. The final print (opposite page) was made by exposing the mill with the number 3 filter and the water and sky with the number 1 filter, achieving a tonal balance impossible with paper having a single degree of contrast.

number 3 filter

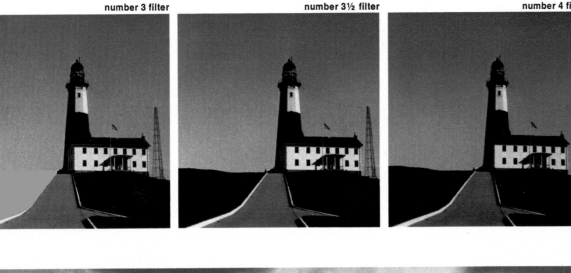

number 3½ filter

number 4 filter

Variable contrast paper can produce seven different degrees of contrast, as shown at left, with a set of seven filters. The contrast range is equivalent to paper grades 1 through 4—rising by half steps. The contrast that is given by a number 2 filter is generally considered to be "normal." Two ways of inserting filters in enlargers are shown below. A filter-holder can be attached to the lens of the enlarger by means of rubber-tipped screws. One of the filters from the numbered set that comes with this attachment is then slipped into the holder (below, top), and can be easily changed if another grade of contrast is desired. Some enlargers have a special filter drawer (below, bottom) located between the lamp and the negative. A filter—which has been cut to the appropriate size from an acetate filter sheet—is inserted, the drawer closed and the print made.

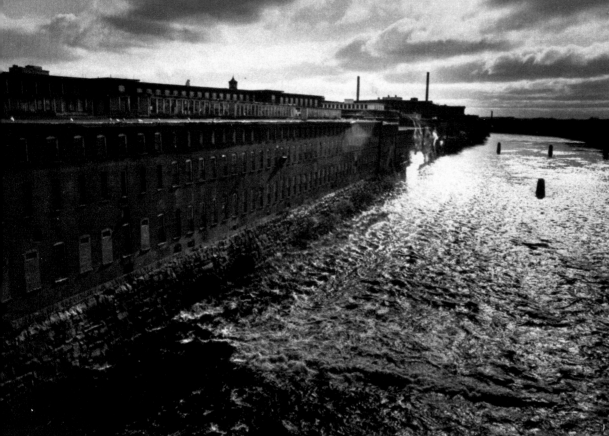

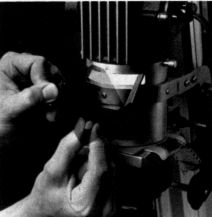

Tips on Printmaking

Every photographer works out his own refinements of the basic steps of printmaking. Here are some, suggested by the TIME-LIFE Photo Lab, that will help the beginner.

Vignetting. To surround an image with a dark background—an effect popular for portraits—try "vignetting." After the initial printing exposure is made, but before development, hold your fist over the subject's image and turn enlarger on. Start with your fist fairly close to the enlarger lens, then lower it, wiggling it slightly, to the paper surface. Finish the procedure in about five to 10 seconds, then process the print as usual.

Cropping. Two pieces of cardboard cut in the shape of a block letter "L" can be arranged one on top of the other to form an open rectangle of variable size. Placed over a contact print, the pieces can be moved to indicate how the picture changes as different degrees of "cropping" include or leave out portions of the scene.

Selective development. Part of a print can be darkened during development by increasing the temperature at that spot. Breathing on it while holding it in the palm of your hand will warm it enough; so will rubbing the front of the print with your finger. To darken a large area, try localized development: pull the partly developed print out of the tray, rinse it with water and swab the area to be darkened with cotton dipped in concentrated developer.

Prolonging the life of fixer. Rather than one tray of fixer, use two trays side by side. Prints are passed from the stop bath to the first tray, left for about five minutes, then transferred to the next for three or four minutes. The greater part of the fixing action takes place in the first tray; the second tray ensures that the last undeveloped, unexposed emulsion crystals are dissolved. When the fixer in the first tray is chemically exhausted, it can be replaced with the lightly used solution from the second tray.

Reducing washing time. An agent called fixer neutralizer, or hypo-clearing agent, sold in photographic supply stores, removes fixer from prints by chemical action. It cuts washing time and water consumption by at least 50 per cent.

Storing printing paper. Keep the paper in a light-tight box in a cool, dry place, to prolong its life. Stray light "fogs" paper—gives it an overall gray tinge that shows up most noticeably in the unexposed margin of a finished picture. Time and heat do the same. Most paper will last about 2 years at room temperature without showing deterioration. But if kept in a refrigerator, it keeps considerably longer.

Brightening fogged paper. If a print comes out fogged, add commercial antifog solution or a few drops of 10 per cent potassium bromide solution to the developer before using any more of the same batch of paper. These solutions prevent fog from appearing.

Reducing. A solution of potassium ferricyanide crystals—about one eighth teaspoon to eight ounces water—causes a chemical reaction that removes some of the silver in an image, brightening it. Take the print out of the fixer after about a minute and swab the part of the print that is too dark with cotton dipped in reducer. To stop the reducing action, re-immerse the print in fixer and then wash it thoroughly.

Toning. Some prints, particularly portraits and landscapes, look better if the image has a subtle tone of color instead of the usual gray. Color tone can be controlled by the paper and developer used (pages 106-107). But a much greater variety of colors is obtainable with special toning agents. These liquids are applied by dipping the print into a tray of toner after the print has been thoroughly washed but while it is wet. The most common tones are the rich browns called sepia, which add warmth to a picture even if applied very lightly. Also common is blue toning which increases sparkle and brightness, having the same effect on images that laundry blueing has on family linen.

Mounting prints for display. The best way to attach a print firmly to a stiff backing—so that it can be hung on a wall, for instance—is with dry mounting tissue. This is a very thin waxy sheet that adheres when heated. Lay the print face down on a table and cover its back with a piece of tissue. Set a household iron between the temperatures marked for silk and wool and touch its hot tip to the corners of the tissue. Now trim the tissue to the same size as the print. Position the print face up on the mounting board, cover the assembly with thin cardboard and press firmly with the iron. A curled print should be dampened on its back with cotton and redried under light pressure between blotters.

Modern Masterpieces 4

Great Printmakers of Today 122

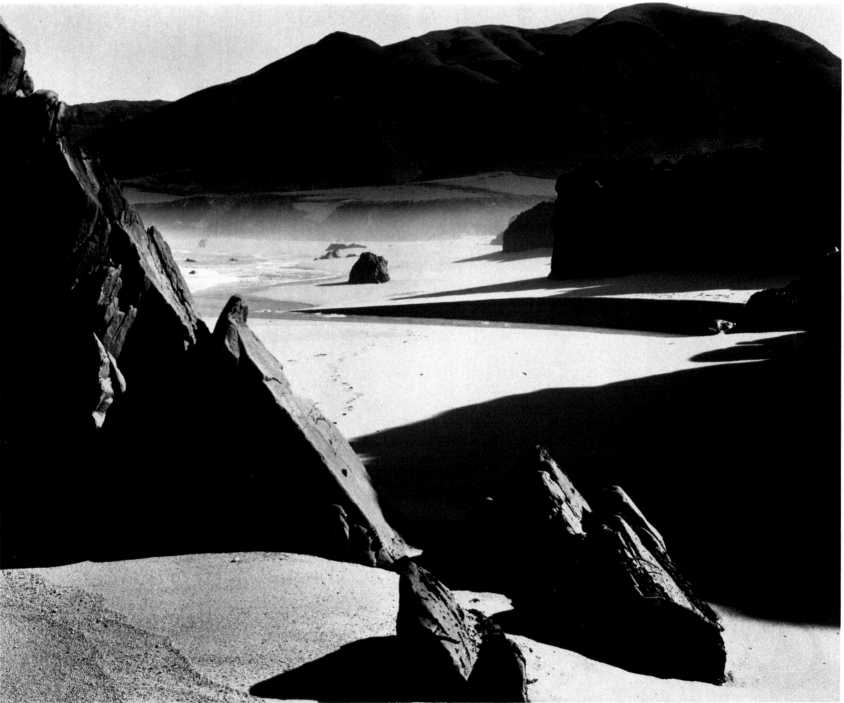

BRETT WESTON: *A contact print from an 8 x 10 negative of Garapata Beach, California, 1954*

Great Printmakers of Today

They are only a handful. Among the millions of amateur and professional photographers around the world, the master printmakers may total no more than a few hundred. Yet their influence is out of all proportion to their numbers, for it is they who carry photography into the halls of museums, galleries and salons, where their pictures are matted, framed and hung to be savored by the senses in much the same way a painting by Rubens, Rembrandt or Picasso would be. The heritage upon which the master printmaker builds is, in photographic terms, a long one. For these photographers are the artistic descendants of Stieglitz, Käsebier, Coburn, Edward Weston and the other creative photographers who, in the first decades of this century, led the battle for photography's acceptance as a medium of art *(Chapter 1)*.

There are many characteristics that bind today's creative photographers together into a recognizable group. Among these is an almost fanatic attention to detail at every level of the photographic process—from composing the picture right through to the selection of a particular grade of enlarging paper. Perhaps even more characteristic, however, is the fact that every successful printmaker has developed a faculty for what photographers call "prevision"—that is the ability to look at a three-dimensional scene and see in the mind's eye how it would appear in the two-dimensional format of the photographic print. This is no simple trick, for it requires not only creative imagination but also a complete and sure familiarity with all the equipment, the materials and techniques available for bringing an idea to fruition. There are literally thousands of variables. Each camera, each type of film, of developer, of printing and enlarging paper has its own special characteristics, and the interplay of these variables, together with the photographer's choice of aperture, shutter speed and other elements of timing, determines in large measure whether or not his print will be a success. Upon the photographer's calculations of such mechanical factors depends the outcome of his artistic intentions.

Every master printmaker has evolved a style of his own that is best suited to portray his unique vision of the world through the medium of photography. To the collector of photographic prints, a picture by Harry Callahan *(pages 154-155)*, Brett Weston *(page 121)* or Minor White *(pages 128-129)* needs no written signature, for the photographer's personality infuses the print itself. Still, for all the personal quality that each brings to his work, most can be classified in a general way as sharing with other printmakers one of three broad philosophical approaches to photography. There are those like Bill Brandt *(pages 156-157)* for whom the negative is merely a starting point toward the creation of a print. They will use any photographic means they have at their disposal, radically altering reality as necessary to produce the pictures that they have imagined. The result may have little apparent

relationship to the negative—or, for that matter, to anything else except an artist's idea. Other photographers such as Jack Wellpott *(pages 144-145)* aim to reproduce the scene as they saw it. They use such darkroom tactics as dodging and burning-in not to alter reality but to make the print reproduce the reality they had seen in front of the camera.

Finally, there is a group of master printmakers who stand at the opposite pole from those who create their pictures with the enlarger, for they eschew even the slightest deviation from the image captured in the camera. Some will not even use enlargers, but instead rely on 8 x 10 contact prints. To them, the challenge lies in reproducing in the print exactly the image recorded in the negative. This requires painstaking attention to the details of print-making techniques—the choice of paper and developer, the regulation of printing exposure. One among them goes so far as to measure, with a laboratory instrument, the density of each part of a negative before he decides the best way to print it.

A leader of this purist school of printmaking is Brett Weston, whose reputation as an artist-photographer now rivals that of his famous father Edward. Weston considers the print used as the frontispiece of this chapter as among his finest. His recollections of how it was made reveal his method of working. Early one foggy morning on a beach near his home in Carmel, California, he was studying close-ups of rock formations with his 8 x 10 view camera. Suddenly the rising sun topped the coastal hills and burned into the blanket of vapor. Like a print in a tray of developer, the image of the beach began to emerge from the dissipating blanket of mist. Weston, realizing that he must work with unaccustomed speed, hurriedly positioned his tripod and camera as he saw forming on the ground-glass viewing screen the scene he later would print. The faint shapes of distant hills appeared and grew dark and massive; sharp shadows etched the forms of beach rocks and bluffs deeper and deeper against the contrasting white sand. At the precise moment when the three elements—light, mist and shadow—were all exquisitely balanced within the format of his ground glass screen, Weston exposed his sheet of Isopan film.

Later he made exactly the same kind of judgment when, working in his darkroom under the dim glow of a yellow safelight, he seized the moment of perfection to stop the development of the contact print, plunging it into a tray of stop bath just as the visual impression he had glimpsed on the beach was reborn on richly toned Azo grade 2 printing paper.

On the pages that follow, each of the three approaches to printmaking is represented by the work of some half dozen of today's most highly rated photographers. Each photograph is the particular choice of its creator, who, like Weston, printed it especially for reproduction in this volume.

JEAN-LOUIS SWINERS: *Portrait of a Boy,* 1960

Jean-Louis Swiners' career has been a meteoric one. By the time he was 22 he was already a staff photographer for the French picture magazine *Réalités* and was establishing a reputation as one of Europe's leading photojournalists with such unusual picture essays as "Paris as Seen by a Dog," a series of pictures taken from the ground looking up. Today an editor and freelance photographer, he is renowned in France and the world over for his creative work with both the camera and enlarger.

The picture at left is typical of the results Swiners obtains by his careful evaluation of the scene, the negative and printing technique. A 1960 portrait of Swiners' brother-in-law—today a painter and musician, but at the time still in his early teens—it glows with a soft overall gray, concentrated largely in the middle tones. There are no deep blacks or brilliant whites in the picture. The scene, as it had existed before Swiners' camera, had been even more muted—"open shade" is his description of the lighting conditions. But to reproduce these soft lighting effects Swiners had to increase the contrast of his negative somewhat. He printed his 35mm negative on Ilford Multigrade paper using a number 3 filter, which is the equivalent of normal contrast. Had Swiners printed with less contrast, the result would have been a flat drabness; had he increased the contrast more than he did, he would have produced an ordinary-looking sharpness of tone instead of the warm and gentle firmness that makes this print so lifelike.

Roger Mertin

Although he is one of the youngest of America's master printmakers, Roger Mertin, born in Connecticut in 1942, undertakes complex pictures that require virtuoso control of darkroom processes. The picture at right is one that Mertin counts among his finest. It shows a television screen floating in a black void over a reclining female nude, and was taken by aiming his 35mm Nikon camera, equipped with a wide-angle 28mm lens, into a mirror. Reflections from the mirror can be seen along the model's leg, in the foreground, and buttocks.

"When I made this photograph," explains Mertin, "I was interested in exploring the possibilities of pictures within pictures." He used this approach to express, with powerful visual impact, the confrontations that perplex modern man: between female and male, between the sensual and the cold, between nature and artifice.

With a picture like this, depending so heavily upon intellectual interpretation for its impact, meticulous care in printing was of primary importance. Mertin used Brovira grade 4 paper for high contrast. He stopped down his enlarger lens to f/11, so that he could give a total exposure of 18 seconds, time enough for burning-in and dodging. After exposing enough to bring the flesh tones of the model to the desired degree of darkness, Mertin gave the television-screen portion of the print extra exposure. This made it stand out strongly, in sharp contrast to the delicate delineation of the girl's form and the rich, velvety black of the detailless background, so that the model and television image seem to hang in space.

ROGER MERTIN: *From "Plastic Love-Dream,"* 1968

Hisae Imai

"Yes, I am a printmaker," says Hisae Imai. This petite young woman's talent for printing has helped make her one of Japan's leading photographers —no small achievement in a male-dominated nation where photography is a national passion. "I'm forever engrossed with the magic of photography and I do everything—double exposure, triple exposure, montage, using color and black-and-white negatives together—to make the print an artistic success," Miss Imai says. But her adventurousness begins before the film is exposed: "I am always looking for objects of strange beauty, and finding them, I want to express them." In the picture at the right, she herself helped to create the "strange beauty" by painting the body of her nude model in the bright colors and the intricate floral designs of spring and then festooning her with flowers.

Miss Imai made her picture in bright sunlight on Tri-X film with a Hasselblad 500c, exposing for 1/60 second at f/5.6. This combination of fast film, full light, moderately large aperture and relatively slow shutter speed produced an exceedingly dense negative and accounts for the pale, almost bleached quality of her print, made on grade 3 paper to add some contrast. The overall printing exposure was 15 seconds, but to introduce what she calls "subjectivity" to the photograph—that is, her very own personal expression—she gave added exposure to the face and the area around the model's breasts, creating a composition of lights and lesser lights that differs somewhat from that in the negative.

Miss Imai's ability to bring out in the photographic print subtle gradations of tone and texture reflects, in large measure, her training as a painter. But she is the daughter of one of Japan's prominent portrait photographers, and gradually she fell under the spell of camera and enlarger. However, she still looks back wistfully on her days as a painter and considers photography only one among several "means of expressing my internal self."

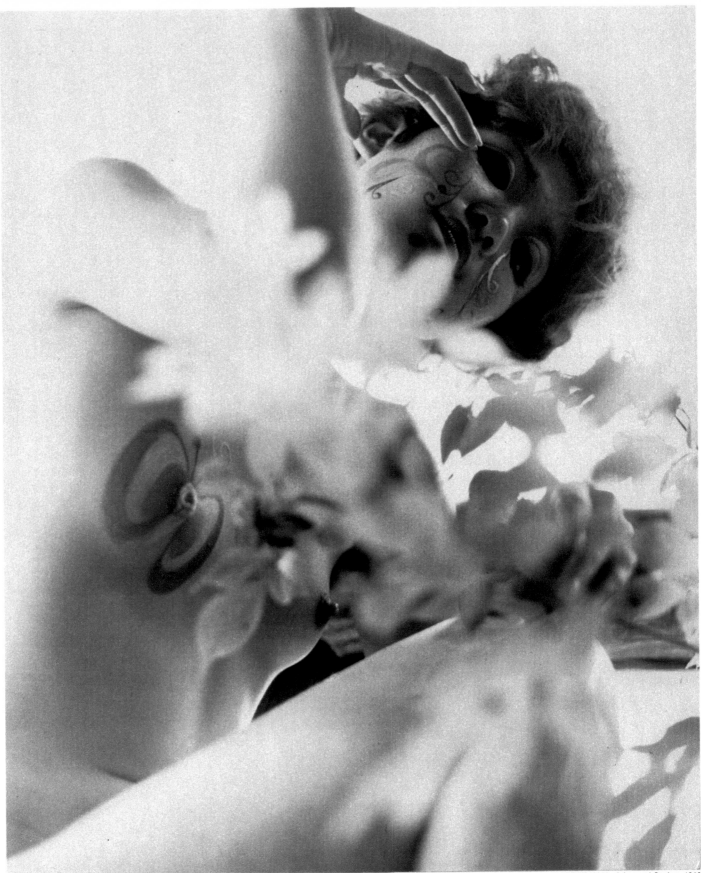

HISAE IMAI: *A Lass of Spring*, 1969

Philippe Halsman

Since his arrival in the United States from his native Latvia in 1940, Philippe Halsman has established an international reputation as one of the world's foremost portrait photographers. One hundred of his studies of the world's famous have graced the covers of LIFE magazine. Besides great skill with camera and darkroom equipment, Halsman has a genius for establishing quick and easy rapport with his subject—whether an aging actress worried about her wrinkles or a prime minister impatient with posing. Once they are engaged by Halsman's informed conversation, his camera is forgotten, the mask of self-consciousness drops and the photographer goes to work.

Halsman remembers that when the accompanying picture of Albert Einstein was made in 1947, he and the scientist were discussing the atomic bomb. Einstein, caught up in the ideas they were talking over, reflected in his expression sorrow over the destructive use of his theories—and at that moment Halsman tripped the shutter. The picture won immediate acclaim and it remains the most popular likeness of the famous physicist. A United States postage stamp was even based on it.

In making the print Halsman faced the problem of registering the details of the scientist's snowy hair while preventing the skin tones from becoming too dark. To do this he slightly overexposed and underdeveloped his negative, thus toning down the contrast. He printed the picture on variable contrast paper, using it without a filter so that it gave medium contrast overall, and gave the whole picture an exposure of 12 seconds. He then exposed the hair and the background for an additional four seconds. This extra exposure—provided to those areas alone while Halsman held his fist over Einstein's face—was necessary because, despite his precautions during development of the film, the hair would have turned out too light and the objects in the background have become distracting.

Although Halsman finds the medium tones of variable contrast paper used without a filter esthetically pleasing, it does not always suit all parts of a picture. By using a filter while burning-in or dodging portions of the negative, he controls overall contrast to an exact degree and also can vary that contrast from one part of the print to another. With the Einstein portrait, however, he burned in the hair and background without a filter, since reducing the contrast with a soft, low-contrast filter would have made the hair become a dull gray, while increasing the contrast with a hard filter would have made it look like straw.

PHILIPPE HALSMAN: *Portrait of Albert Einstein,* 1947

Jack Welpott

A large-paned window in a room in an old house, a round oak table set with the remnants of breakfast, a Victorian mirror, a sketch pinned to the wall, a lumpy couch, a young girl—the random elements of a random morning make up the photograph at right. At first glance it seems to be nothing more than a lucky snapshot. In reality its complex balancing of lights and darks was meticulously created in the darkroom. Its creator, a professor of photography at San Francisco State College, has exhibited his work in numerous galleries and museums, including the George Eastman House in Rochester.

Jack Welpott took the picture with a 4 x 5 view camera. He placed it high on a tripod "to emphasize the position of the objects—each in its place and in relationship to every other object." The girl is the picture's center of attention. Her image appears three times—on the couch, as a reflection in the mirror and as a sketch on the wall—her pensive expression and lowered head in all three manifestations helping to establish an atmosphere of brooding tension. "The round table," says Welpott, "stabilizes these conflicts. The image is filled with commonplace objects which react to each other in uncommon ways —it becomes a sort of dialogue between objects."

In order to get maximum detail despite the relatively dim light—the only illumination came from the room's single window—Welpott closed down his lens to f/32 and made an exposure that lasted four seconds. "I exposed for the shadows and then underdeveloped the negative by 45 per cent to reduce contrast. Had the negative been fully developed, all of the surface texture in the highlights—particularly around the window—would have been lost."

Close scrutiny of this picture reveals a secret of the printmakers' art. Notice the relative brightness of the seated girl and her reflected image. The reflection is brighter than the girl herself, although ordinarily a mirror reflection is a bit darker than the object it shows. The explanation is that Welpott, in making his enlargement, held back the exposure in the dark, right-hand side of the picture to keep detail in the mirror frame and in the deep shadows around the right-hand side of the table. By doing so, he lightened the reflected image of the girl as well, calling attention to it and at the same time underscoring the tension that is the picture's theme.

JACK WELPOTT: *Anna in Her Room*, 1964

PAOLO GASPARINI: *May Day Celebration, Havana, 1961*

Paolo Gasparini, whose photographs now grace the collections of The Museum of Modern Art, Eastman House and the Polaroid Corporation, was born in Italy, but has made his greatest impact with pictures on Latin American themes. His attitude toward his subject matter stands in stark contrast to that of other modern printmakers. "Among all the tendencies of photography," Gasparini says, "realism is the only valid one, because the drama of the world is more important than the intimate feelings of the artist." It was partly with this credo in mind that Gasparini chose to live in the turbulent atmosphere of revolutionary Cuba from 1961 to 1965, despite the persistent unavailability of many basic photographic materials.

"I was interested in living and participating in the revolutionary movement," he says, "and naturally I wanted to get it down on film." For the picture at left, taken during the 1961 May Day celebration in Havana, Gasparini used the only film available—Super-XX, a motion-picture film that does not give the grain and contrast usually demanded of still negatives. "Limitation of technical resources," Gasparini says, "did not, in my case, become a frustration. Quite the contrary, it served to free me from overattention to technical details and allowed me a more flexible position toward historical events."

In making this picture, Gasparini wished to convey a sense of excitement and joy. He set his shutter at a relatively slow speed, 1/60 second, "so as to capture the movement of the hands and the flags but without running the risk of freezing the action and taking away the vitality of the gestures." Such a shutter speed in the bright Havana sunlight made parts of the negative very dense and caused great contrast between the lightest and darkest areas. To compensate, Gasparini printed the negative on his last remaining sheets of paper with rich tonal gradations. He explains, "I further tried to resolve the problems of contrast and density by starting with an exposure of 30 seconds for the entire surface of the print, dodging some exposure from the darker areas, while giving at least ten times more exposure to the light areas of the sky." Thus, by emphasizing latent tone and texture through painstaking printing, Gasparini was able to transform what might have been a routine news photograph into a print that powerfully expressed the enthusiasm of the Cuban crowd.

Duane Michals

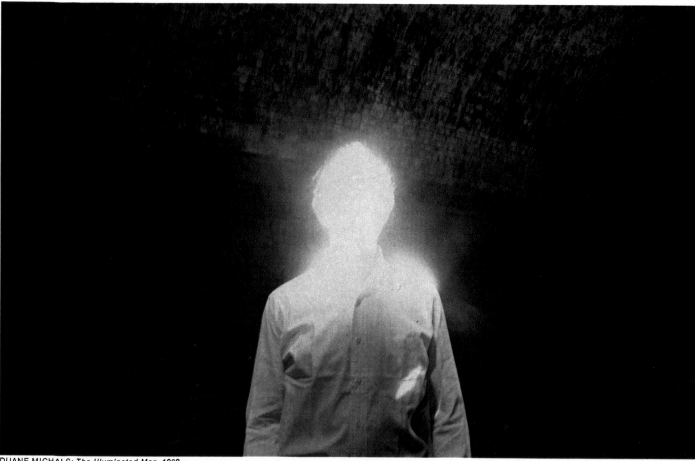

DUANE MICHALS: *The Illuminated Man*, 1969

"I wanted to do a photograph of a man whose head would dissolve into pure light—as if his spiritual energy or aura could be seen, while his features were obliterated," is the explanation Duane Michals gives for this deliberately unbalanced photograph. Michals, one of the most inventive of a new generation of photographers working in New York City, posed a friend in the automobile tunnel on Park Avenue just south of Grand Central Station, standing him where his head was spotlighted by a shaft of sunlight that penetrated from the street above. Michals mounted his 35mm Nikon F camera on a tripod, loaded it with Tri-X film and made a long exposure calculated to capture the mottled texture of the dim tunnel wall. But the face, in full sun, was at the same time greatly overexposed.

Michals, one of the very few creative photographers who does not choose to develop his own film, directed his laboratory to develop the roll normally. Then he printed the picture on grade 6 paper with an exposure of 20 seconds. The very high contrast of this paper em-phasized grain, produced deep black tones and made the light area an au-reole of white.

The very great overexposure in the negative of the highlighted face caused the streaked aura of white in the print. This effect, accentuated by graininess, makes the light appear in particles that suggest a sunburst, just as Michals had intended it should. Only in the subject's shirt—which was given a few seconds' extra exposure—is there any great amount of detail, its re-creation of tex-ture a foil for the featureless face. □

Images Created in the Darkroom 5

YALE JOEL: *Self-portrait, some of its tones reversed by solarization and lightened by treatment with chemical reducer,* 1969

WILLIAM HENRY FOX TALBOT: *Cameraless shadow picture of field flowers, 1839*

reality in the negative, he made prints in which negative and positive views were shown side by side—two parts that form a whole. He also produced a beautiful abstract motion picture called "Lightplay Black-White-Gray." Filmed long before anyone thought of psychedelic light shows, it pictured a light-display machine having various surfaces—some opaque, some transparent, some brilliantly reflecting—as they were moved about by an electric motor. The viewer received an impression of pure form and light in motion, growing, fading, shifting into new shapes and rhythms.

Most of this experimentation took place during the '20s, when Paris and Berlin viewed each other as centers of artistic ferment. By the '30s, Europe was clearly heading into an era even more cruel and senseless than that of World War I. The Nazi press described the Bauhaus as a breeding ground of Bolshevism, and on April 11, 1933, storm troopers charged into the school, ostensibly to search for Communist pamphlets. Three days later, in the grim, cold dawn of Good Friday, the SS called at the house of John Heartfield to pick him up for arrest. Hearing their voices, the man who had continued to satirize Hitler in his photomontages jumped out the bedroom window. Shoeless, he began his flight over the mountains to Czechoslovakia. Man Ray was able to live peaceably in Paris until the Nazis occupied the city—and then he had to flee to America.

Moholy-Nagy, too, found refuge in the United States. He founded a second Bauhaus in Chicago, and his ideas about the language of light, together with the freewheeling work bequeathed by Heartfield and Man Ray, have now inspired a whole new generation of photographers. And once more imaginative experimentation with the print is demonstrating how much more than a faithful record of nature a photograph can be. □

Carol Schwalberg

From the Radio Tower, 1928

The extreme-angle shot—a picture made looking straight down or straight up at the subject—was only one of the modern approaches to photography pioneered by László Moholy-Nagy. For the picture above he aimed his camera directly downward from the top of the Berlin radio tower. From that unusual perspective the snow-covered courtyard, the partially cleared walk, the bare trees and the foreshortened building all lose their identity to unite in a single design of abstract beauty.

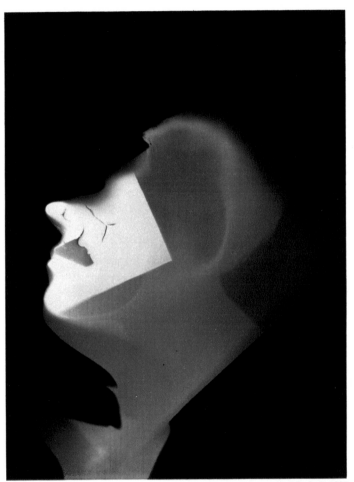

Self-Portrait, 1925

The shadow images of the photogram and the multiplied images of the photomontage enabled Moholy-Nagy to contrast the real and the abstract in provocative ways. The photogram above is a shadow of his own head on printing paper. He created the bright wedge-shaped segment by inserting an ordinary piece of paper between his head and the printing paper for part of the exposure. The photomontage at right combines pieces of five photographs into a satiric comment on society, suggesting that the structure of the world may be only a flimsy scaffolding supporting a leg-show and a scared monkey for an audience of clacking pelicans.

Structure of the World, 1925

Far-out Prints of the Avant-Garde

The same spirit of adventure that produced such unusual photographs after World War I—transforming the print with shadow images, multiple-exposure composites and reversed tones—blazed anew in the 1950s. A few years earlier another terrible war had come to an end, and once again the avant-garde began trying out new concepts, new materials and new methods.

This resurgence of experimentation with the print gained its momentum at a time when the old distinctions between photography, painting and sculpture were vanishing, particularly among the boldly unconventional creators of "pop art." Utilizing the everyday images of technological society, they made paintings that looked like blown-up comic-strip panels and road signs, composed portraits of strips of pocket-size photographs and mounted gigantic photographs on cutouts and boxes. While the photograph was helping stir up the ferment of pop art, a like ferment gave the photographic print itself different forms—all grounded in the photograph, but frequently borrowing techniques from printing, engraving, painting, even the tricks of old-time photographers, to create striking images of fantasy, beauty or heightened realism.

What is remarkable about modern transformations of the print is their range. The techniques perfected during the 1920s are still widely used, but now they are often varied and combined.

The two methods of reversing tones—solarization and negative printing—may be used together to make a single print (pages 206-207, 212-213). Shadow pictures, also known as photograms, have in their turn become the basic subject matter for the multiple images of photomontages (page 220).

Other manipulative techniques have been introduced from the field of commercial printing. Some pictures are reproduced by an adaptation of the silk-screen process, while others rely on materials ordinarily employed for lithography and photoengraving.

Along with these modern processes are some resurrected from earlier days of photography. Gum-bichromate emulsions, used by Edward Steichen and others in the early 1900s to give a print the appearance of a watercolor (pages 44-45), are now often used to create wholly original images with vibrant tones (pages 222-223). And unusual pictures are made by printing directly from a drawing made on a translucent base—a technique that antedates the invention of photography (page 210).

How adaptable such vintage procedures are to modern treatment is demonstrated by Robert Heinecken's mysterious photogram shown on the opposite page. Simply by putting a page from a magazine on a sheet of sensitive paper and exposing it to light long enough to capture the images from both sides of the page, he created a small world that is part Dante and part Disney. A white ghost in an ornately flowered dress seems to be trying to escape the grasp of a black woman.

Such sophisticated use of old and new processes, either singly or in combination, is producing some of the most interesting prints on view today. And as the darkroom has once again become the seedbed for avant-garde creativity, printmakers all over the world press the search for new ways to express themselves and to increase the dimensions of their medium.

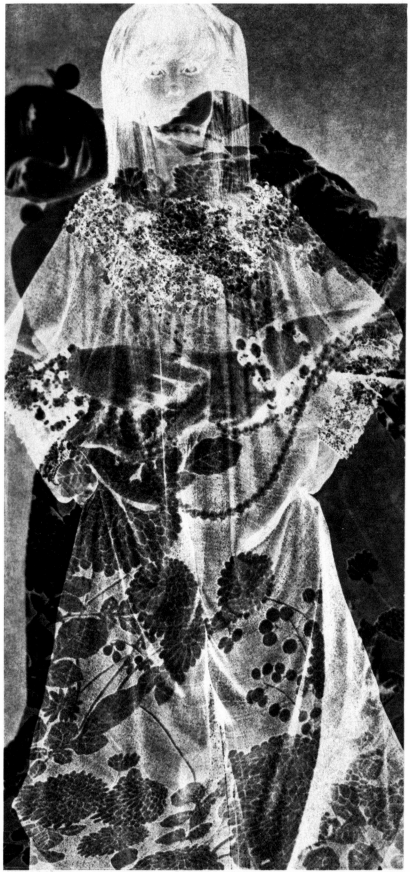

ROBERT F. HEINECKEN: *From "Are You Rea,"* 1964-1968

Far-out Prints of the Avant-Garde: continued

Hand Coloring: The Disputed Art

"A rank perversion of photography," said the conventional photographers. "A dreadful imitation of painting," said the artists. Such were the reactions that greeted the hand coloring of daguerreotypes in the early years of photography, and the passage of many decades has done nothing to temper the response of purists to the adding of color to black-and-white photographs.

But in the hands of an artist like Harold Jones, the result is not an imitation of nature but an artifice that adds a new dimension to the print. Authenticity is of small concern to Jones, who often uses artificially vivid transparent colors to strike a note of whimsy (a green cow appears in one of his prints). In the picture shown here, only the central figure is tinted (with food coloring, the kind used for frosting on birthday cakes). The woodsy scene surrounding the girl remains black and white, a background that converts a natural and sedately posed figure into an enigma. □

HAROLD H. JONES III: *Primeval Dress*, 1968

Bibliography

Techniques

Adams, Ansel:
 Camera and Lens: The Creative Approach.
 Morgan & Morgan, 1970.
 The Negative: Exposure and Development.
 Morgan & Morgan, 1968.
 The Print. Morgan & Morgan, 1968.
Cory, O. R., *The Complete Art of Printing and
 Enlarging,* Amphoto, 1969.
Eastman Kodak:
 Basic Developing, Printing, Enlarging.
 Eastman Kodak, 1962.
 Kodak Master Darkroom Dataguide.
 Eastman Kodak.
 Kodak Photographic Papers.
 Eastman Kodak, 1967.
 *Processing Chem.cals and Formulas for Black
 and White Photography.* Eastman Kodak, 1963.
Eaton, George T., *Photographic Chemistry.*
 Morgan & Morgan, 1965.
* Floyd, Wayne, *ABC's of Developing, Printing
 and Enlarging.* Amphoto.
Focal Press Ltd., *Focal Encyclopedia of
 Photography.* McGraw-Hill, 1969.
Fraprie, Frank R., and Florence C. O'Connor,
 Photographic Amusements. The American
 Photographic Publishing Co., 1937.
* Harris, E. W., *Modern Developing Techniques.*
 Fountain Press.
Heist, Grant, *Monobath Manual.* Morgan &
 Morgan, 1966.
* Hertzberg, Robert, *Photo Darkroom Guide.*
 Amphoto, 1967.
Jacobson, C. I., *Developing: The Technique of
 the Negative.* Amphoto.
Jacobson, C. I., and L. A. Mannheim, *Enlarging.*
 Amphoto, 1969.
* Jonas. Paul, *Manual of Darkroom Procedures
 and Techniques.* Amphoto, 1967.
Lootens, Ghislain J., *Lootens on Photographic
 Enlarging and Print Quality.* Amphoto, 1967.
Mees, C. E. Kenneth, and T. H. James, *The
 Theory of the Photographic Process.*
 Macmillan, 1966.
Moholy-Nagy, L., *Vision in Motion.* Paul
 Theobald, 1947.
Neblette, C. B., *Photography: Its Materials and
 Processes.* D. Van Nostrand, 1962.
Pittaro, Ernest, *Photo-Lab-Index.*

Morgan & Morgan, 1970.
Pocket Darkroom Data Book No. 2. Morgan &
 Morgan.
Rhode, Robert B., and Floyd H. McCall,
 Introduction to Photography. Macmillan, 1966.
Satow, Y. Ernest, *35mm Negs & Prints.* Amphoto,
 1969

History

Camera Work, Alfred Stieglitz, New York City,
 1903-1917.
Doty, Robert, *Photo-Secession.* George Eastman
 House, 1960.
Gernsheim, Helmut, *Creative Photography:
 Aesthetic Trends 1839-1960.* Faber & Faber Ltd.,
 1962.
Lyons, Nathan, *Photography in the Twentieth
 Century.* George Eastman House, Horizon
 Press, 1967.
Newhall, Beaumont, *The History of Photography.*
 The Museum of Modern Art, Doubleday, 1964.
Scharf, Aaron:
 Art and Photography. Penguin Press, 1968.
 Creative Photography. Reinhold, 1965.

Biography

Frank, Waldo, *America and Alfred Stieglitz.*
 Doubleday, Doran & Co., 1934.
Gernsheim, Helmut and Alison, *Alvin Langdon
 Coburn: Photographer.* Frederick A. Praeger,
 1966.
Lyons, Nathan, *Photographers on Photography.*
 Prentice-Hall, 1966.
Moholy-Nagy, Sibyl, *Moholy-Nagy,
 Experiment in Totality.* The M.I.T. Press,
 1969.
Newhall, Nancy, ed., *The Daybooks of
 Edward Weston.* George Eastman House,
 1961.
Norman, Dorothy, *Alfred Stieglitz.* Duell, Sloan
 and Pearce, 1960.
Ray, Man:
 Self Portrait. Little Brown, 1963.
 Photographs 1920-1934 Paris. Random House,
 1934.
Seligmann, Herbert J., *Alfred Stieglitz Talking.*
 Yale University, 1966.
Steichen, Edward, *A Life in Photography.*
 Doubleday, 1963.

Photographic Art

Barr, Alfred H., Jr., *Fantastic Art, Dada,
 Surrealism.* The Museum of Modern Art, Simon
 & Schuster, 1947.
Bry, Doris, *Alfred Stieglitz: Photographer.*
 Boston Museum of Fine Arts, 1965.
* *Contemporary Photographs.* UCLA Art Galleries,
 1968.
* *Five Photographers.* University of Nebraska,
 1968.
John Heartfield. Institute of Contemporary Arts,
 London, 1969.
László Moholy-Nagy. Museum of Contemporary
 Art, Chicago, 1969.
Lyons, Nathan, ed.:
 The Persistence of Vision. George Eastman
 House, Horizon Press, 1967.
 Vision and Expression. George Eastman
 House, Horizon Press, 1969.
Man Ray. Los Angeles County Museum of Art,
 1966.
Photography, USA. DeCordova Museum,
 Lincoln, Massachusetts, 1968.
† Rubin, William S. *Dada, Surrealism, and Their
 Heritage.* The Museum of Modern Art, New
 York Graphic Society, 1968.

Periodicals

Aperture, Aperture Inc., New York City
British Journal of Photography, Henry
 Greenwood and Co., London
Camera, C. J. Bucher Ltd., Lucerne, Switzerland
Camera 35, U.S. Camera Publishing Co., New
 York City
Creative Camera, International Federation of
 Amateur Photographers, London
Infinity, American Society of Magazine
 Photographers, New York City
Modern Photography, The Billboard Publishing
 Co., New York City
Popular Photography, Ziff-Davis Publishing Co.,
 New York City
Travel & Camera, U.S. Camera Publishing Corp.,
 New York City
U.S. Camera World Annual, U.S. Camera
 Publishing Corp., New York City

* Available only in paperback.
† Also available in paperback.

Acknowledgments

For the help given in the preparation of this book, the editors would like to express their gratitude to the following: Thomas F. Barrow, Associate Curator, Research Center, George Eastman House, Rochester, New York; Peter C. Bunnell, Curator, Department of Photography, The Museum of Modern Art, New York, New York; Walter Clark, Rochester, New York; David L. Cooper, Consumer Service, Berkey Marketing Companies, Inc., Woodside, New York; John Co-rey, Executive Assistant, Beseler Photo Marketing Company, Inc., East Orange, New Jersey; Patrick Datre, Arkin-Medo, Inc., New York, New York; Robert M. Doty, Associate Curator, Whitney Museum of American Art, New York, New York; Albert E. Elsen, Department of Art History, Stanford University, Palo Alto, California; Gerald Jacobson, New York, New York; Harold Jones III, Associate Curator, Exhibition and Extension Activities, George Eastman House, Rochester, New York; Tom Lovcik, Department of Photography, The Museum of Modern Art, New York, New York; Nathan Lyons, Photographic Studies Workshop, Rochester, New York; Charles Reynolds, Chairman, Department of Photography, School of Visual Arts, New York, New York; Jerry Scarrett, PCI Publications, Eastman Kodak Co., Rochester, New York and Lawrence Shustak, Instructor, Department of Photography, School of Visual Arts, New York, New York.

Picture Credits

Credits from left to right are separated by semicolons, from top to bottom by dashes.

Index

Printed in U.S.A.